W9-AUU-344

Mapping Cities

CATALOGUE AND ESSAY BY NAOMI MILLER

EXHIBITION COORDINATED BY KAREN E. HAAS

BOSTON UNIVERSITY ART GALLERY

JANUARY 14–FEBRUARY 25, 2000

UNIVERSITY OF WASHINGTON PRESS ⚬ SEATTLE AND LONDON

Boston University Art Gallery
855 Commonwealth Avenue
Boston, Massachusetts 02215

© 2000 by Trustees of Boston University
All rights reserved.
"Mapping Cities," © 2000 by Naomi Miller
All rights reserved.

Distributed by the University of Washington Press
P. O. Box 50096, Seattle, Washington 98145

Printed in the United States of America
Library of Congress Catalogue Card Number: 99-75502
ISBN: 1-881450-13-9

COVER ILLUSTRATION: John Bachmann, *New York and Environs,* 1859, Eno Collection, Miriam and Ira D. Wallach Division of Art, Prints, and Photographs, The New York Public Library, Astor, Lenox, and Tilden Foundations

Contents

Acknowledgments

I would like to thank Naomi Miller, Professor of Art History at Boston University, for conceiving of this wonderful exhibition and for working on all aspects of the catalogue. At every step in the organization and realization of *Mapping Cities*, she has maintained her characteristic wit and humor, which has made this project a pleasure.

David Cobb, Director of the Harvard University Map Collection, has been generous with his time, insight, and guidance; this exhibition could not have happened without his support and the help of his staff.

The Boston University Art Gallery is grateful to Professor Katherine T. O'Connor and the Humanities Foundation of the College of Arts and Sciences, and Graduate School, Boston University, for their support of this catalogue.

I would also like to acknowledge the contributions made by Kimberly Shilland, Curator of Architectural Collections at the Massachusetts Institute of Technology Art Museum; Joseph Garver, Reference Librarian, Martin von Wyss, Digital Cartographer, and Conservator Louise Baptiste from the Harvard University Map Collection; Roger Stoddard, Curator of Rare Books, Anne Anninger, Curator of Prints and Graphic Arts, and Librarian William M. Stoneman at the Houghton Library at Harvard University; Mary Daniels, Special Collections Librarian, Loeb Library, Graduate School of Design at Harvard University; Alice Hudson, Chief of the Map Division, Roberta Waddell, Curator of the Print Collection, Robert Rainwater, Curator of the Spencer Collection, and Eileen Coffey, Loan Services Administration, Exhibition Program Officer, all from the New York Public Library; Roberta Zonghi, Keeper of Rare Books and Manuscripts, and Eugene Zepp, Reference Librarian, at the Boston Public Library; Marjorie B. Cohn, Carl A. Weyerhaeuser Curator of Prints at the Fogg Art Museum, Harvard University; Steve Nonack, Head of Reference, and Sally Pierce, Curator of Prints and Photographs at the Boston Athenaeum; Roni Pick, Administrative Assistant, and Alex Krieger of Chan, Krieger and Associates, Curator of the Norman B. Leventhal Map Collection; Ken Totah and Stanhope Framers; Gail English, Preparator, Museum of Fine Arts, Boston; Margaret Brown, Exhibitions Registrar, and Ronald Grimm and James Flatness, Geography and Map Division, Library of Congress; and Forbes Smiley.

I also wish to thank Spelman Evans Downer, Gary Hilderbrand, Joyce Kozloff, and D. C. Moore Gallery, New York, J. H. Aronson, Jane Hammond, J. J. Edwards at ULAE, Curtis Woodcock from the Boston University Department of Geography, and the Perry Casteneda Library, University of Texas, Austin.

This exhibition emerged from a seminar that Professor Miller taught in the spring of 1998 in the Department of Art History at Boston University. I wish to extend my thanks to all of the students who participated in that class and who provided a forum in which the ideas that informed *Mapping Cities* were greatly refined. The participants included Olivia Fagerberg, Jennifer French, Madhuri Ravi, Chris Chanyasulkit, Milica Curcic, Giorgio Bulgari, and Jana Peretz.

The Art Gallery staff has worked diligently on this project, and I am particularly grateful to Curator Karen E. Haas for the care with which she has coordinated all of the loans for the exhibition and edited the essays in this catalogue. I also thank our Gallery Assistant Julie Marchenko for her dedicated service on this project and our other staff members who have all made contributions, including Michelle Lamunière, Catherine L. Blais, Wendy Stein, Andrew Tosiello, Rachel Hyman, Emily Moore, Sarah McGaughey, Denise Kaplan, Katrina Jones, and Chris Newth.

John R. Stomberg
Director

Hardly a more diverse group of seven students could be imagined in terms of background, geographical distribution worldwide, and career goals. Four were Class of 1998, two were graduate students, and one an Evergreen (Metropolitan College) student. Each member of the seminar was required to write a thematic essay focusing on the essence of the city as manifest in its topography and history. The thrust of these essays has been maintained to reflect each student's individuality. Following introductions to local collections, the students chose the maps and submitted descriptive analyses. Some of these excellent "catalogue entries" do not appear, as the goals of the exhibition changed, or loans were unavailable.

Special thanks to Kim Sichel, former director of the Art Gallery, and to Keith Morgan, former chairman of the Department of Art History, who encouraged the seminar forming the basis for this exhibition. Above all, I am most grateful to the staff of the Art Gallery, to John Stomberg, director; to Julie Marchenko, graduate assistant/summer intern, who became a "virtual" member of the seminar; and to graduate assistant Chris Newth. Infinite gratitude extends to two people, without whom this exhibition and catalogue would not be possible. David Cobb, Director of the Harvard University Map Library, made the treasures of this superb collection available for study and for loan, and generously shared his knowledge and expertise with all involved. Among curators, Karen Haas is second to none, possessing a most discerning eye and astute judgment, while maintaining the highest standards and keenest responsibility in attending to the smallest details and the "grand design."

In addition to those named in John Stomberg's acknowledgments, I have benefited from contact with colleagues and friends who have broadened my horizons in the field of cartography, and thus have contributed to the pleasure and production of this work in progress, namely, David Buisseret, Ed Dahl, Matthew Edney, Nitza Rosovsky, and John Willenbecher. Thanks are also due to institutions, the sponsors of map conferences and exhibitions, particularly the Newberry Library, Chicago; the Folger Shakespeare Library, Washington, D.C.; the New York Public Library; and the Cooper-Hewitt National Design Museum, New York.

To all the people and institutions who helped with this project, I am deeply indebted, for the great privilege to venture into known and unknown territory. Responsibility for errors remains entirely with the instructor. To the students, this catalogue is dedicated.

—Naomi Miller
Professor of Art History

Mapping Cities

What could be more pleasant than, in one's home far from all danger,
to gaze in these books at the universal form of the earth . . .
adorned with the splendor of cities and fortresses and, by looking at the
pictures and reading the texts accompanying them, to acquire knowledge which
could scarcely be had but by long and difficult journeys?

—Georg Braun, *Civitates Orbis Terrarum*, 1581

I. INTRODUCTION: URBAN CARTOGRAPHY

Hardly surpassed for variety and delight, the six-volume atlas edited by Georg Braun, from 1572 to 1617, constitutes a watershed in urban mapping. Its 546 bird's-eye views and town prospects worldwide have become a fundamental source for the study of cities. Reflecting on the idea of cities as bastions of civilization, these views were as concerned with pictorial beauty as with the practical uses ascribed to maps.

To study maps of a specific time and place is analogous to studying a language, a means for the transmission of spatial data. Beyond verbal descriptions, maps communicate the essence of an actual place by transferring a spherical body to a two-dimensional plane. This type of representation is reinforced by the etymology of the words *map* and *cartography,* the former from the Latin *mappa* meaning cloth and the latter from the Greek word signifying the drawing of charts and maps, a document on parchment or paper. A map as a representation, usually on a flat surface, may be distinguished from a view, "the sight or prospect of some landscape or extended scene."[1]

Who has not used a city map? Yet, despite its ubiquity, urban cartography is a relatively recent discipline, quite distinct from the field of urban history. The term itself came into use after World War II, at which time it dealt with the production of maps representing the formal, historical, and functional conditions of urban agglomerations, thereby paving the way for conceiving new patterns of town planning.

Maps in this exhibition range in date from ca. 1500 to the present. We should like to emphasize the idea of the city map as a bearer of information, a graphic means of communication, and a means of potential discourse. No more vivid testimony to the omnipresence of maps can be seen than in daily news broadcasts. Apparently, maps provide the spatial and the visual contexts for events. By now, the sophisticated viewer, aware of the incredible range of photographic and verbal machinations, is surely cognizant of the selection of data, the manipulation of facts, and the reception among diverse audiences. Few mental maps of cities reveal a greater subjectivity than Saul Steinberg's bicoastal view of the United States—an extreme example of the city as seen by its inhabitants contrasted with "reality." Hence, a caveat is in order regarding maps as purveyors of objective reality. Witness Mark Monmonier, author of *How to Lie with*

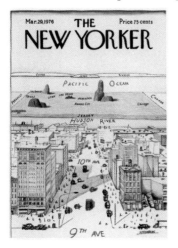

FIGURE 1

Saul Steinberg, *A View of the World from Ninth Avenue, March 29, 1976.* Copyright 1976 The New Yorker Magazine, Inc. Reprinted by permission of the Estate of Saul Steinberg/ Artists Right Society (ARS), New York, and The New Yorker Magazine, Inc.

Maps: "A single map is but one of an indefinitely large number of maps that might be produced for the same situation or from the same data."[2] Maps may be drawn to provide false data to military enemies, to camouflage terrain, and to assist in intelligence operations. Some of the earliest engraved views of towns in atlases, ca. 1543, appeared in conjunction with military events.[3] At all times, it is crucial to note the origin of the map, the function for which it was created, and the information included, as well as that omitted. Today, when even maps of continents and regions are considered biased, and when the focus is on maps as instruments of power, as a means to conquer and control the world, this exhibition surely may be justly accused of a Eurocentric bias. With the extended definition of maps as "cognitive systems," or rhetorical devices, cultural predispositions take on a charged significance.[4]

Is there any other form of representation that provides more data about a city? Because there is no single work that traces the broad history of city maps from the Renaissance to the present day, it is hoped that the presentation and accompanying catalogue might serve as guides for future studies. It is the main purpose of the exhibition to act as a ready reference to varieties of urban cartography in form, function, and as works of art that are accessible to the amateur and specialist alike. For the latter, speculation as to the course of development of urban mapping is bound to raise questions about the cartographic legacy, as also the celebration of its subject, the city, as the acme of civilization. For the uninitiate, who constitute the majority, the exhibition should promote knowledge and understanding, and an increased awareness of problems and parallels today. Above all, in the spirit of Braun's atlas, four centuries ago, we hope that this paean to cities will provide edification and evoke wonder and delight.

RATIONALE FOR THE CHOICE OF SEVEN CITIES

At first, the exhibition bore the title "Seven Cities," the number seven charged with symbolic magic. Neither the appellation, nor the choice, nor the number of cities was arbitrary, the latter also determined by the class register. Each student in a curatorial seminar in spring 1998 was assigned a city—namely, Jerusalem, Rome, Amsterdam,

Paris, London, New York, Boston—and the work of these students forms the core of the exhibition, particularly the catalogue entries. It must be mentioned at the outset that the quest was for original maps, with a minimum of facsimiles, and that our search would be restricted, with few exceptions, to local collections.

What is the rationale for the city maps herewith included? Briefly, in early medieval maps, Jerusalem is placed at the center of the world; further, it is the goal for religious pilgrimages and for conquering Crusades. Hence, it constitutes an ideal beginning, being that some of the oldest surviving maps depict this city. In the realm of cartography, Jerusalem is eventually superseded by Rome, both as the pagan and the Christian city par excellence, whose mapping history comes to the fore with accounts of its marvels in the late Middle Ages. Whereas the creation of relatively scientific maps has its inception in the rediscovery of Ptolemy's *Geography* in the humanist circles of fifteenth-century Florence, it is only in the two centuries following that mapping enters the modern sphere. Not surprisingly, Amsterdam, as a navigation hub, becomes the locus of the map trade with the works of Mercator and Ortelius, and later, the city atlas of Blaeu. In the eighteenth century, the center of geographic science shifts to Paris. Ground observation and instrument surveying techniques were used by geographers and scientists, who at mid-century marked the transition from speculative mapmaking to precise documentation in accord with triangulation.

As a constantly growing and dominant maritime and commercial power, England soon takes the lead in mapmaking. Admiralty surveys, ward maps, fire insurance maps, and a variety of thematic maps become part of the font of eighteenth- and nineteenth-century cartography, which includes pictorial and practical maps of London. About the same time, maps of towns in the American colonies appear with greater frequency. Prior to the Revolutionary War, many are military maps, executed by surveyors of the British army. Others, such as those in Joseph des Barres's *Atlantic Neptune,* ordered by the king, were compiled for the use of the Royal Navy of Great Britain, 1744–1800. Its finely delineated charts, printed in eight volumes, became the standard guide for navigation of the eastern coast of North America. The maps herein are still noted

for their topographical detail, which serve as decisive historical records. Maps of New York demonstrate its phenomenal growth in the New World, influenced too by a speculator's plan. And, because Boston is our point of departure and a one-time maritime city, its presence here is self-evident.

II. Beginnings: Antiquity to the Renaissance

Two problems appear uppermost in the study of historic city maps. One concerns a "continuous tradition" from ancient times, the other the evidence of scale maps.[5] A wall painting from Çatal Hüyük, ca. 6200 B.C., depicts a city plan, as do clay tablets from Babylon, where a plan of Nippur, ca. 2000 B.C., apparently drawn to scale, shows the Euphrates River, temples, and surrounding walls. Pictorial maps exist from ancient Egypt, and like the earlier Mesopotamian maps, their function was probably connected to property rights and the settlement of boundary disputes.

Town maps drawn to a consistent scale in China have been found dating from the third century A.D., and sufficient evidence implies an earlier date. Phei Hsiu, cartographer in charge of imperial works in A.D. 267, gives a detailed description of the method used in creating a map of the empire, namely, drawing a grid of equidistant lines.[6] In China, mapping was often classified among the elite arts, ennobling the city depicted.

Evidence for orthogonal planning is found in Greek towns in Asia Minor, where a grid pattern is used as a means of surveying—a method often attributed to Hippodamus of Miletus in A.D. 479. Under Roman rule, mapping was assigned to the land surveyors (agrimensores), who divided the land by means of centuriation (based on a system of squares; in towns, these squares are called insulae, or blocks), a means established throughout the empire, as indicated in early Latin treatises. This Roman division of land is visible in the elaborate topographical layout of the Forma Urbis Romae, a large-scale plan of Rome, A.D. 203–11, carved on marble and once attached to a wall (approximately 42 ft. high x 60 ft. wide). Extant fragments number 679, and inscriptions identify important public buildings. Although drawn to scale, inconsistencies appear,

some perhaps due to particular features such as aqueduct arches, which are shown in elevation rather than in plan. Thus, the Romans joined the pictorial tradition of mapmaking to survey maps drawn to scale.[7] Like other monumental building projects and institutional reforms, this large-scale map, and earlier ones recorded under Augustus and Vespasian, were intended to convey anew the grandeur and the glory of the Roman Empire.

Plans of cities survive in the Byzantine world, none more renowned than the mosaic of Palestine and surroundings, from Damascus to Alexandria. The enormous Madaba map (16 x 34 ft., named after its site in a church in Transjordan), ca. A.D. 565, depicts a biblical landscape with ten cities in bird's-eye view, including a particularly vivid representation of Jerusalem. The two colonnades of the Roman cardo and the Church of the Holy Sepulcher are clearly distinguished. Later, maps of Rome and Constantinople are documented as being made during the reign of Charlemagne.

During the Middle Ages, we find a considerable legacy of city maps—as vignettes in manuscripts, as maps to the Holy Land in the time of the Crusades, and as both celebratory and territorial maps of Italian cities perhaps tied to the revival of Roman urban life in the late medieval communes. Other maps were in a laudatory mode, such as the ninth-century view of Verona, which may be linked to a metrical poem "Versus de Verona," a panegyric to the city. Encomia in praise of Italian cities dating from the twelfth century parallel contemporary city maps. Examples include maps of Milan in manuscripts, a fresco on the wall of a chapel in Sant' Antonio in Padua, and a map illustrating a popular civic laudation as the Mirabilia Urbis Romae, 1143. District maps of northern Italy begin to proliferate in the fourteenth and fifteenth centuries—Venice and the lagoon from Paolino Veneto's Chronologia Magna, an early fourteenth-century copy (probably after a twelfth-century map drawn to scale) and a fifteenth-century map of Verona in its territory. The possibility of ties with northern ateliers is apparent in a plan of Vienna, ca. 1422. Literary descriptions such as a letter from a Florentine lawyer describing a lost plan of Florence, 1377–81; a city ideogram of Rome incised on the Barbarossa seal, 1152–90; and Ambrogio Lorenzetti's frescoes, the Allegory of Good and Bad Government, 1338–40, on the walls of Siena's

Palazzo Pubblico—all provide further evidence of city views.[8]

Mapmaking in the Renaissance corresponds to maritime power and wealth. At the height of its commercial prosperity, Italy is in the forefront. Increased exploration, combined with the rediscovery of manuscripts of ancient texts, especially Ptolemy's *Geography,* led to a new era in cartography. Ptolemy's world map, supplemented with regional and town maps, used a coordinate system (the grid of perspective), thereby supplanting medieval sea charts. However, few works had as great an impact on Renaissance architecture and town planning as Vitruvius's *Ten Books on Architecture,* rediscovered in the early fifteenth century. Written in the Augustan age, it is the only surviving

FIGURE 3

Leonardo da Vinci, *Plan of Imola,* 1502, by permission of the Royal Library, Windsor Castle, copyright Her Majesty Queen Elizabeth II

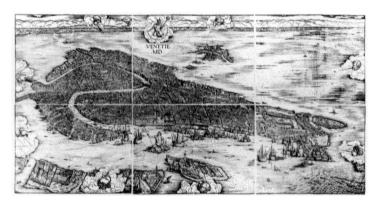

FIGURE 2

Jacopo de' Barbari, *View of Venice,* 1500, copyright The British Museum, Department of Prints and Drawings

treatise on architecture that records building practices of the ancients. In Book I, Vitruvius discusses the plan of the city, its site, and layout with enclosed circular walls and towers, designed strictly for defensive purposes. To Renaissance architects, its geometric form reflected the Platonic ideal of cosmic perfection and harmony. But by far the greatest impetus to the increase in the map trade was the invention of printing, which allowed for a widespread distribution of hitherto rare works. The *Catena* map of Florence, produced in that city by Cosimo Rosselli, ca. 1482, is a bird's-eye view of the Renaissance city, exhibiting scale relationships, the urban determinants and significant buildings seen in relation to the local vernacular. Other fifteenth-century representations of Italian cities—Naples, Rome, and Genoa—show an increased awareness of scale relationships. But little prepares

us for the stupendous cartographic achievement of Jacopo de' Barbari's map of Venice, dated 1500. Grand in dimensions (4 x 9 ft.) in six woodcut blocks, here is the city recreated as a work of art, a tribute to its prosperity and power. The early-fifteenth-century invention of perspective by Brunelleschi and its exposition by Alberti made this great leap toward a more methodologically rigorous cartography possible, one concerned with proportional relationships, that is, with measured drawings. The view of Venice is only two years away from Leonardo da Vinci's ichnographic (the delineation of streets and buildings drawn in outline, as in a ground plan) map of Imola, 1502. In both the Venice and Imola maps, several sketches from different vistas "have been plotted onto a perspective framework which itself may have been calculated from ground plans of the city similar to those used by the Venetian authorities for maintenance of roads and canals."[9] A military map, strictly drawn to scale, the *Plan of Imola* is the first such map since the Roman era, but mindful too of medieval conventions, such as the directions of the winds. Set within a circle, its circumference marked by 64 degrees, Leonardo's map pays homage to the cosmological principles of an older era, while at the same time effecting a revolution in mapping. In this ichnographic plan, Imola "is represented as if viewed from an infinite number of viewpoints."[10]

III. Development of town mapping, ca. 1500 – 2000

1. Pilgrimage maps—Medieval to Renaissance: Jerusalem, Rome

Prior to the Renaissance, town mapping was strongly tied to medieval philosophical schema. For example, the position of Jerusalem in *mappaemundi* or in city ideograms, namely, as a circle of turreted walls, was a commonplace representation in late medieval paintings and manuscripts. In world maps, Jerusalem is indicated at the center, a tradition that survives throughout the sixteenth century. Representing the city as a circle within which is a quadripartite division, Crusader maps convey a symbolic perfection to those embracing Christianity, and later, to those espousing Neoplatonism. The form of the circle common in medieval T=O maps dates back to the seventh century, wherein a *T* within a circle separates the earth into three continents with the Mediterranean Sea and rivers between. Moreover, this idea of circularity is transferred to images of Rome in manuscripts, medallions, coins, and maps, as well as frescoes and paintings in churches and palaces. Few images are more beguiling than the representation of Rome in the prayer book *Très Riches Heures,* made for Duke John of Berry by the Limbourg Brothers in 1416, now in the Musée Condé, Chantilly.

An increase in urban mapping came with the application of printing techniques to cartography. Breydenbach's account of his pilgrimage to the

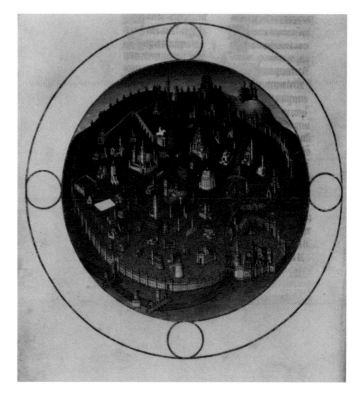

FIGURE 5

Pol de Limbourg, *Le Plan de Rome,* from the *Très Riches Heures du duc de Berry,* 1416, Musée Condé, Chantilly, courtesy of Photothèque Giraudon

Holy Land, published in 1486, shows a marked degree of topographical accuracy in the depiction of cities, from Venice enroute to Jerusalem, in this first known illustrated travel book. A most popular compendium of town views among incunabula is Hartman Schedel's *Nuremberg Chronicle,* 1493, a sacred and profane history containing 1,800 woodcuts. About one-fourth of the 116 views are recognizable; however, most towns are illustrated by seventeen blocks, which became the standard type for several cities. This relative indifference to distinctions among cities also appears in Sebastian Münster's *Cosmographia,* 1544, although here the older views are supplemented and updated by the author's own observations.

A remarkable woodcut plan-view of Tenochtitlán, the city that was created during the reign of Montezuma I, shows its cruciform layout, its many canals, and its temple precincts. Hernando Cortés's letter to Charles V describes his conquest of the Aztec capital in 1521. An accompanying drawing forms the basis of this earliest printed plan of an American city, on the site of today's Mexico City.[11]

FIGURE 4

T=O Map of Augsburg, 1472, courtesy of Chicago, Newberry Library

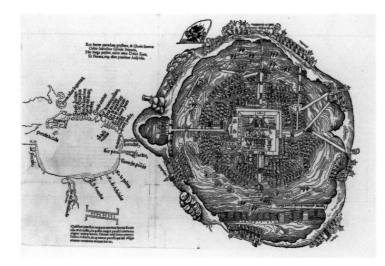

FIGURE 6

Hernando Cortés, *View of Tenochtitlán*, from
La preclara narratione di Ferdinando Cortese della Nuova Hispagna,
1524, courtesy of Library of Congress

2. TOWARD A SCIENTIFIC CARTOGRAPHY: DISSEMINATION OF ATLASES IN THE NETHERLANDS

Not surprisingly, in a transitional era from pictorial and empirical to a more scientific cartography, considerable retardataire tendencies coexist with new developments that incorporate more accurate instrumentation and measurement. The science of perspective, hinted at but not truly employed in the 1500 view of Venice, appears in the north in Cornelis Anthoniszoon's woodcut view of Amsterdam, 1544, which prefigures the obsession with mapping in Dutch seventeenth-century art.

By the mid-sixteenth century, the new technique for drawing scale maps by triangulation, led to the plan of Rome by Leonardo Bufalini, 1551, the work of a surveyor, military engineer, and amateur antiquarian rather than an artist—in comparison with the bird's-eye view, the "picture map" as exemplified by Jacopo de' Barbari.[12] However, both types of maps are evident in the Low Countries, where the art of cartography was most fully developed in the late sixteenth and seventeenth centuries. Here, the great mapmakers Ortelius and Mercator produced their world atlases, and families of cartographers flourished, notably the Janssons, the Visschers, and the Blaeus, who published city maps as well. Entering the provenance of a rising burgher class, maps

once more become objects for collectors in addition to serving their more traditional functions for expanding commerce, geographic exploration, and leisure travel. Elaborate cartouches and allegorical figures often create a cultural context for maps and parallel a new literary genre devoted to accounts of voyages, far and near.

Drawing on such precedents as the splendid bird's-eye views, but with increased awareness of scale drawings, the *Civitates Orbis Terrarum*, published in Cologne, provided a companion to Ortelius's *Theatrum Orbis Terrarum*, 1570, the systematic collection of world maps. Georg Braun edited the *Civitates*, and most of the engravings and plans of cities worldwide were executed by Frans Hogenberg, although many town views already in circulation were used. Through their widespread diffusion (and accompanying translations), the maps became prized possessions for their owners; each was an image of the city displaying its unique characteristics, its resources, its inhabitants, its mores—in short, a slice of life—despite the often free interpretation of the living actualities, as marked by measured surveys. Braun manages to inject a military agenda in his text, when he expresses the hope that cities under Turkish dominion would be reconquered by Christian armies, and, too, in his representation of the human body, which was off limits to Muslims. Hardly could the appreciation that greeted Braun's work be better expressed than by Robert Burton in his *Anatomy of Melancholy*, 1621:

> To some kind of men it is an extraordinary delight to study, to looke upon a geographicall map and to behold, as it were, all the remote provinces, towns, citties of the world...what greater pleasure can there be then...to peruse those books of citties, put out by Braunus and Hogenbergius [sic].

Our greatest fascination today, as in the seventeenth century, is to gaze down upon an entire city—a miniature wonderland—and thereby read its contents. These plan-perspectival views of the building fabric and street plan—a type of ichnographic view that later became an isometric (or axonometric) view—are based on earlier sixteenth-century maps, which partially accounts for

the lack of consistency among the maps, in addition to the distorted distances.

Joan Blaeu (1596–1673) (son of Willem Janszoon, founder of the great printing house in Amsterdam, who learned about the art of instrument and globe making as an assistant to the astronomer Tycho Brahe) took over the family business and is most known as publisher of sea and world atlases. Blaeu also produced a two-volume *Atlas of Towns* in the Netherlands in 1649. It was Blaeu's family who published the *Atlas Major* or *Theatrum Orbis Terrarum* of 1635, which appeared in many languages. It is among the most lavishly decorated of seventeenth-century atlases, known in several editions as the result of collaboration between surveyors and artists. His atlas of 1663, presented to Louis XIV, with words that "geography [is] the eye and light of history," has sometimes been deemed the most beautiful geographical work ever printed.[13]

3. EIGHTEENTH-CENTURY FRANCE: CENTER OF TOPOGRAPHICAL SCIENCE

Whereas there was a growing market for world atlases in sixteenth-century France, and a few notable artistic maps (Finé, Thevet, Appian) appeared, it is with the reign of Henri IV that maps came to be considered primarily as conduits of royal power. Earlier associations of maps with an elite class are hereby reinforced. Still, a number of maps of Paris exist from the sixteenth century, enabling us to follow the growth of the city; these include atlases and the plan, ca. 1535, known through a copy in a tapestry woven in 1569–88 for Cardinal Charles de Bourbon. The rebuilding of Paris by Henri IV is recorded by military engineer Vassallieu dit Nicolay, 1609, and much enhanced in the copperplate published by Jean Le Clerc in the atlas *Le théâtre géographie du royaume de France*, 1619. "Paris as it was in 1620," engraved by Matthäus Mérian, was reissued by his son Kaspar and appears in Martin Zeiller's *Topographia Galliae* in 1655. Here one sees the plazas created by Henri IV and the beginning of development on the Ile St.-Louis.[14] A Mérian plan of 1615 bears the inscription *Ceste [sic] ville est un autre monde, dedans sa monde florissante*—an allusion to the city as a microcosm of the world.

Powerful nation states created new demands for maps that contained more factual content. French cartography expanded with the rise of nationalism under Louis XIV and peaked in the eighteenth century, when Paris became the center of a geographical science, based on exact measurements and ground observations. As in Holland, we see the dominance of cartographic dynasties, among the most prominent being that of geographer Guillaume de l'Isle (1675–1726), Premier Géographe du Roi (First Geographer of the King) in 1718, who based his findings on triangulation (cf. Brunelleschi's perspectival innovations). Organized by the French Academy and supported by Louis XV, Jacques Cassini's *Carte géométrique de la France* (182 sheets), begun in 1744, applied these scientific findings to map all of France. Maps of

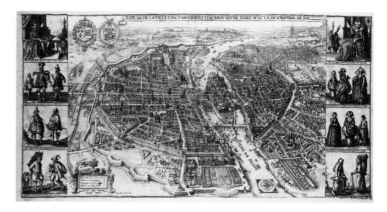

FIGURE 7

Matthäus Mérian, *Le Plan de la Ville Cité Universiteet Fauxbourgs de Paris, avec la Description de son Antiquité*, 1615, courtesy of the Kunst Museum, Basel

this period were often embellished by artists (Boucher, Cochin, Gravelot), continuing the well-established pictorial tradition.

4. EIGHTEENTH- AND NINETEENTH-CENTURY ENGLAND: MARITIME, COMMERCIAL POWER

Long before the great age of English cartography (admiralty surveys, triangular distance tables, road maps, meteorological charts, and geological maps), we find a strong legacy of city mapping. A convenient starting point is Matthew Paris's depiction of London on his itinerary map to southern Italy, ca. 1252. In accord with an early pictorial tradition, London is drawn with other towns as a walled

city, but distinguished by such landmarks as St. Paul's Cathedral and the Tower.

An early plan of London, 1553–59, on fifteen copper plates, was copied by Hogenberg for his map view in the *Civitates,* 1572. Braun's map of Tudor London is the earliest known printed map of the city, showing its extension from Shoreditch to Southwark and from Westminster to Whitechapel. This view of London, ca. 1560, includes the spire of St. Paul's Cathedral, which was destroyed by lightning in 1561. Among pre-fire representations, Visscher's panoramic view of the city seen from Southwark in 1616, the year of Shakespeare's death, also features St. Paul's and the Tower Bridge. Pictorial evidence of the seventeenth-century city may be found in royal entry books and in paintings, such as one showing the coronation procession of Edward VI in 1547.[15]

Engravings by Wenceslaus Hollar depict the city before (1647) and after the Great Fire (1666), the latter produced by John Overton, employing a multiplicity of bird's-eye views; areas destroyed are shown as blank blocks, the others with buildings, but it is "a simple plan, drawn to uniform scale, on which the pictures of buildings have merely been superimposed." How different is the "large and accurate map of London" by John Ogilby and William Morgan in 1676, "London's first true plan," in which the streets and houses are to scale in order "to settle boundary and property disputes and to portray the new buildings." Accompanied by a booklet, with a brief history of the city, the map also showed the speed with which the city had been rebuilt. It is noteworthy that Ogilby consulted Robert Hooke, astronomer, mathematician, and Curator of Experiments of the Royal Society, regarding surveying and mapping techniques.[16]

Characterized by notable improvements in surveying techniques, the eighteenth century witnessed the production of far more accurate maps, a "marvelous palimpsest"—a record of the modern landscape and of "successive stages of historical process that brought the landscape into being," as writ by William Maitland in a preface to his *Survey of London,* to account for the omission of a map of the city. Maps of wards, those administrative units convenient for surveying that have divided the city since Norman times, were often enhanced by inset views of significant buildings and monuments (see John Strype's *Survey of the City of London and Westminster,* 1720).[17]

John Rocque, a Huguenot who settled in England, was the most famous cartographer of the eighteenth century: "His town plans were surveyed by trigonometrical observations from towers and other tall buildings and by checking the results with instrumental measurements of angles and distances taken on the ground," and were often embellished with pictorial data in the margins.[18] He published a large-scale map of London in twenty-four sheets in 1746, in addition to maps of principal cities in Europe and America. Other well-known maps of London include those of Thomas Jefferys (d. 1771) and the fine plans by the prolific mapmaker John Cary, ca. 1800.

5. LATE-EIGHTEENTH-CENTURY AMERICA: LINKS BETWEEN CARTOGRAPHY AND WARFARE

In England, the establishment of the Board of Ordnance of the trigonometrical survey was crucial for British urban mapping. Surveyors of the British army were preoccupied with military intelligence before the American War of Independence. Gaining control of the Hudson River was a goal of British campaigns, a fact that surely motivated the execution of the absolutely ravishing Ratzer map, depicting the city within the harbor; on one version an engraving below shows a bucolic landscape from Governor's Island, while a magnificently framed cartouche lists the significant sites. Lieut. Bernard Ratzer surveyed the city of New York and its environs in 1766 and 1767, issuing the plan of New York in 1770, reissued in 1776, both showing great tracts of open land, and the beginnings of a rectangular street plan, soon to become the city's dominant aspect. Based on the Montresor plan, the Ratzer plan is "perhaps the finest map of an American city produced in the eighteenth century ... [marked by] its geographic precision combined with highly artistic engraving...."[19]

Interest in the mapping of American colonies produced a detailed map of the shoreline at this time. And, as John Reps has pointed out, urban development was suspended with the occupation by British troops.[20] During the American Revolution, New York was "the most thoroughly mapped urban area in America...command center for the

British forces, and constant fear of attack by American forces prompted the production of numerous maps to aid in the defense of the city."[21] Engineer John Montresor's plan of 1766, based on a Bristish military survey made under wartime conditions, contains an inset showing the island of Manhattan in the context of the surrounding harbor and land masses.[22]

Coastal plans of Boston such as those by J. N. Bellin, *Plan de la Ville et du Port du Boston,* 1764, and G. F. L. Frentzel's *Plan of the Harbor and City of Boston,* printed in Leipzig, Germany, in 1776, have been linked to war plans. Their fine draughtsmanship reveals the vulnerability of the inhabited peninsula with its narrow neck, which seems dwarfed by the grandeur of the surrounding harbor.

Published by William Faden, a prolific mapmaker in late-eighteenth-century Britain, the *North American Atlas,* dated 1777, contained military maps, including Montresor's map of New York and Lieut. Page's map of Boston. Discussing the "Faden Campaign Maps" of 1776, as a part of a "public relations war," Augustyn and Cohen find "chilling echoes of American military reporting of the Vietnam War," when a pattern of defeat is presented as victory.[23]

6. Plethora of nineteenth-century maps: Urban growth, new techniques

In the nineteenth century, the phenomenal growth of cities, especially in North America, led to the proliferation in the number and type of maps. Further, the expansion of the urban landscape created new markets and demands for cheaper map reproductions. During this time, there were more accurate ordnance surveys, an increase in travel books, improvements in the urban infrastructure, and, not least, new printing methods. Among the latter, copper engravings of maps, common at the beginning of the century, were soon rivaled by the new technique of lithography, and later by printing from mechanical presses. Illustrated periodicals, such as *Harper's Weekly* and *Frank Leslie's Illustrated News* in the second half of the nineteenth century, were vehicles for conveying the life and times of the era in maps and panoramic vistas.

In England, the Society for the Diffusion of Useful Knowledge published an atlas in 1830–42 of hand-colored, hand-lettered, steel engravings of plan maps. Details of the maps provided a chance to study and compare the original aspects of urban development in selected cities throughout the world, as also the landscape and open spaces in relation to the built environment. Although more utilitarian maps were in demand, cartographers continued to add pictorial elements, principally by depicting important buildings in the margins as frames for the maps. And, in fact, the bird's-eye view often replaced the more scientific mapping of the eighteenth century. For example, a map of Philadelphia in 1803 demonstrates three continuing pictorial elements: the picture as embellishment, the picture as an integral part of the map, and the picture as conventional sign.[24] Few views of American cities are more revealing than those of John Bachmann, who was an artist, publisher, lithographer, and painter. His lithographs of New York and Boston are truly bird's-eye views, approaching in effect those of modern aerial photography.[25]

Topographical surveys, particularly in Europe, produced maps to reveal and analyze social conditions; to chart areas of poverty, disease, and epidemics; to pinpoint unemployment and locations of trades; and to form the basis of statistical surveys showing diverse types of data, such as population movements, religious affiliations, and actuarial statistics. Large-scale mapping supplemented ordnance surveys and became an invaluable aid in the analysis of urban processes.

Universal functions of maps continue to be in service, appearing in ever more sophisticated and specialized guides. Military uses of maps are apparent in the plans of Paris in 1871 during the campaign of the French government army in the suppression of the commune. And maps became increasingly commonplace in everyday aspects of urban life. Details of property rights, known from antiquity, were formalized and continually amended, noting changes in building codes and fire regulations, which were essential for the installation and repair of the infrastructure and, of course, for insurance purposes, because of fire or water damage. Goad insurance maps in Canada and Great Britain, and Sanborn maps in the U.S., were constantly updated. Also, from the mid-1850s, city developers, such as the Metropolitan Board of Works and the railway company, required detailed

maps of London. To this end, entrepreneur Edward Stanford produced survey maps, beginning in 1862 and revised at intervals, that included postal districts, parish boundaries, and sewage systems.

7. TWENTIETH CENTURY: FROM AERIAL PHOTOGRAPHY TO SATELLITE IMAGERY

Space-age mapping has completely transformed the cartographic process. Photography and aviation have been the two fundamental instruments since their application for military reconnaissance in World War I. A great breakthrough in aerial photography is evident in the Fairchild Aerial Camera Corporation's *Survey of Manhattan* in 1921, whose wealth of detail was unprecedented at the time.[26] Consider the method by which this enormous map was composed: the overlapping of multiple vertical aerial photos created a stereoscopic effect, resulting in a complete overview of the city, a photo mosaic (comprised of two or more adjoining or collage-like photos in mounted form, connecting oblique photos termed a *panorama*).[27] The perspectival effect achieved recalls in manner of composition and effect the views of Venice by Jacopo de' Barbari and Imola by Leonardo da Vinci.

An isometric perspective drawing of midtown Manhattan, 1962, in the tradition of oblique views of the Renaissance, is seen in a map by German cartographer Hermann Bollmann (who once drew maps of cities destroyed during World War II). Statistics for this map are staggering: it was based on 67,000 photos, including 17,000 aerial shots that were taken with special cameras.[28] Seemingly, the precision and detail hark back to the above-cited Renaissance maps, even to the variation in scale of the buildings drawn.

A revolution in mapping occurred with the advent of satellites and their accompanying equipment of scanning mirrors reflecting land configurations. A huge graphic relief map by LANDSAT, assembled for NASA by the Department of Agriculture in 1974, constituted the first clear photomontage of the United States. Here the world of mapping is far from the coordinate systems drawn to scale by Ptolemy and interpreted by Alberti in the Renaissance. Cartographers could readily appreciate the advantages of satellite imagery in mapmaking, such as coverage, speed, capacity for revision, geometric fidelity, and suitability for automation. Images of the earth's surface from the air (sent back to earth by means of orbiting LANDSAT satellites) supplied data in digital form, transformed to maps.[29]

In the 1980s, LANDSAT spacecraft faced a rival in SPOT (Système Probatoire d'Observation de la Terre), which produced maps with even greater precision. Once these satellite images, revealing "often hidden details of the environment," were allied to military secrets; now they are readily available to the general public.[30] Today, remote sensing, like all aerial data derived from the electromagnetic spectrum, usually refers to "detectors and their imagery which function outside visible wave lengths of light."[31]

Mapping by means of today's technology may foster the waging of war by remote control. J. B. Harley was surely prescient of NATO operations in Kosovo when he wrote: "Military maps not only facilitate the technical conduct of warfare, but also palliate the sense of guilt which arises from the conduct."[32] Errors in recent conflicts, which resulted from the use of faulty maps for precision bombing, are encapsulated in a headline "Smart Bombs, Dumb Maps," reporting on the air war over Yugoslavia (*New York Times,* 16 May 1999). Note too the heading "U.S. Maps Become Legal Issue in Alpine Cable Accident" that appeared above a discussion of Pentagon maps that had not been sufficiently updated (*New York Times,* 13 March 1999). On the positive side, in 1995 NATO used high-tech maps, the product of satellite imagery and terrain elevation information, to create "a virtual-reality version of the Bosnian landscape that allowed negotiators...to examine geographical features." Thus were boundaries in the peace settlement drawn (*New York Times,* 24 November 1995).

Access to city maps is also one of the current marvels of the Internet. Yahoo has surely replaced Baedeker, but there is enormous room for improvement. Witness Edward R. Tufte's works (*The Visual Display of Quantitative Information,* 1983; *Envisioning Information,* 1990), wherein he notes how maps may obscure rather than pinpoint important data. And though his goal of presenting information in a manner that is revealing, accurate, and more spatially coherent is admirable, the means are often as difficult to decipher—at least for the

nonspecialist — as the vast array of icons on today's computer or on the Internet. Few would disagree with Tufte's main goal, namely, to improve cartographic displays by means of data graphics.

Remote sensing is now at the forefront in the practice of mapping. But as older maps, portolan charts, and atlases recede to the realm of history, artists are mining their inherent beauty, decorative ornamentation, encyclopedic fantasies, and spatial configurations as sources of inspiration. In 1961, Jasper Johns's *Map* used the well-known image of the United States to create a new painted surface. Through their own experiments, artists find maps a means of exploring current aspects of culture, politics, and society. In their works, the city assumes a metaphorical context.

IV. Introduction to the Exhibition: Contents and Omissions

Whatever the impact of this exhibition, the excitement surely lay in the process of discovery and selection. We hope that this enthusiasm will be duplicated in the experience of the viewer. A number of maps initially proposed and researched by the students were unavailable because of limitations of gallery space, a desire to have as broad a chronological spectrum as possible, or the fragility of certain works, which precluded loans.

Part of our good fortune in the selection is due to the superb collections of institutions in Boston and, even more so, to their generosity and willingness to contribute to our enterprise. Because the time span represented here coincides with the advent of printing, we are able to present some of the most outstanding extant examples of urban cartography, especially among the atlases on display.

The following brief descriptions of individual cities are intended to introduce and reinforce the thematic essays and entries drafted by the students in the catalogue.

JERUSALEM

This is Jerusalem. I have set it in the midst of the nations and in countries that are round about her.

—Ezekiel V.5

No city is subject to a more mythic tradition in its maps. History and imagination are far more important than spatial factors, and thus certain religious sites were depicted, others excluded or distorted, in accord with the bias of the mapmakers and/or their patrons. Breydenbach's *Pilgrimage to the Holy Land* of 1486 is here, but the popular *Nuremberg Chronicle* is not. Even more exciting, however, is the large map printed in Leyden, 1598, never before published. Its relation to the map of 1584 by a Dutch priest, Adrichom, is evident, a version of which appears in Braun and Hogenberg's atlas. All the sites illustrate passages from the Old and New Testaments and reflect, too, narrative presentations in Franco-Flemish manuscripts and Netherlandish painting. Precedents also appear for the maps that originate in Augsburg, recalling those maps drawn in manuscripts during the time of the Crusades, when Jerusalem was deemed the center of the world. Political misrepresentation is evident, as Jerusalem is viewed as a Christian city while under Muslim domain. That the British Ordnance survey went far beyond that "sceptered isle" is apparent in Capt. Charles Wilson's map of Jerusalem, with its topographical emphasis in accord with modern mapping. Spurred by the British Mandate, and later by the inception of the state of Israel, mapping of the city and the country exists on a scale commensurate with the city's importance—political, symbolic, and physical—in the contemporary world, and the country's preoccupations with defense systems.

ROME

*But truly I cannot compare the
tremendous ruin of Rome to that of
any other city; this one disaster so
exceeds the calamities of all other cities,
whether these were brought about in
the natural course of things or
wrought by the hand of man.*

—Poggio Bracciolini, *The Inconstancy
of Fortune*, 1430

Unlike cities of Roman conquest, the growth of the
ancient city was generally haphazard in its totality.
However, elements of topography (indicated in the
Marliani map)—the hills, the swamps, and the
Tiber—determined the building of public utilities
controlling water supply and sewerage, which are
incorporated into later designs.

The woodcut incunabular view from Foresti's
Supplementum Chronicarum is dated 1486, the
earliest map in the exhibition, and features the
principal pagan and Christian monuments in
oblique perspective.[33] From the mid-fifteenth

to the seventeenth centuries, from Nicholas V
through Alexander VII, transformations in Rome
are the result of papal edicts to improve the city
and encourage pilgrimages. To this end, new areas
were shaped and new vistas created, at the same
time rerouting the movement of traffic.

Leonardo Bufalini's woodcut plan of 1551
constitutes a milestone in mapping. It is the first
known map drawn to scale since antiquity, in
accord with a measured survey drawing. Almost
two centuries later, in 1748, G. B. Nolli produced
his masterpiece of eighteenth-century Rome, a
map in twelve sections. Forms of the medieval,
Renaissance, and baroque cities have been inte-
grated with those of classical Rome, as have the
exterior and interior spaces. Gone is the ordering
principle: the series of columns and the seeming
regularity of rectilinear spaces punctuated by arcu-
ated forms. Instead, we see the complex syncopated
rhythm, with interior vaulted bays setting up
counterpoints.[34] Nolli's mode of representation,
applicable to more dynamic architectural principles,
inspired the exhibit "Roma Interrotta" of 1979,
wherein participating architects were invited to
devise "interventions" to be inserted into the original

FIGURE 8

Robert Venturi, *Roma Interrotta*, 1979, courtesy of Venturi,
Scott Brown and Associates, Inc., Philadelphia

plan, suggesting new buildings and uses to be integrated within the traditional city—an exercise in urbanism and even in adaptive reuse, but deemed by some critics an elite and irrelevant game.[35] From an administrative viewpoint, Nolli's map emphasized the voids as well as the structures, the ambiguities of interior and exterior, the fragmentary nature of the whole. Hence, its appeal to architects today (e.g., Venturi) is easily comprehensible.

PARIS

The bird's-eye view, which each visitor
to the Tower can assume in an
instant for his own, gives us the world
to read and not only to perceive;
[it] permits us to transcend sensation
and to see things in their structure.
To perceive Paris from above
[the panoramic vision] is infallibly
to imagine a history.

—Roland Barthes, *The Eiffel Tower*
and Other Mythologies, 1979

Often cited as the paradigm of urban design, the plan of Paris is remarkably coherent and consistent, a product of centrifugal growth dating from its beginnings in Roman times. Divisions created in the Middle Ages are still extant. The city was divided into three parts: the Ile de la Cité, site of government and worship; the Left (or south) Bank, the location of the university; and the Right Bank, the "city" or commercial center. From the early thirteenth-century walls of Philip Augustus, the city grew outward in a concentric pattern.

Henri IV's grand schemes, the creation of open spaces according to geometric principles, were superseded by the plans of Le Nôtre, dominated by the cult of the axis. The latter was transferred from the châteaux of Vaux-le-Vicomte and Versailles to Paris under the aegis of Louis XIV. Successive monarchs vied in the embellishment of the city, the results of which can be followed in the course of city maps, beginning with Nicolay and continuing with those of Mérian in the early seventeenth century. Today's Paris is largely the nineteenth-century city as transformed by Napoleon III and Baron Haussmann. Despite the radical innovations wrought, the city remains the product of absolutism. Coupled with the need for new defense boundaries, aesthetic considerations are uppermost, resulting in an adherence to monarchal principles established in the seventeenth century. We see the magnificent plan available both in twenty sheets and in atlas form, commissioned in 1739 by Michel Turgot, Prévôt des Marchands of Paris, the city's chief administrator. Changes in surveying methods and improved instrumentation led to higher standards of accuracy, but surprisingly this most extraordinary map of Paris—drawn, surveyed, and engraved by Louis Bretez—aroused little interest, despite its official imprimatur. Details in the bird's-eye view, such as boat traffic on the Seine, cannot but recall that benchmark in urban mapping, the Jacopo de' Barbari view of Venice in 1500, wherein a highly decorative mode enhances the clarity of the whole.

Focus on geometry, the heritage of Cartesian clarity, survives in the urban interventions of Napoleon I and Napoleon III in the nineteenth century and continues today—witness I. M. Pei's pyramid, the current center of the Louvre, aligned with the long axis leading to the Arch of Triumph and beyond to the Arch of La Défense, the current extension of the city to the west.

AMSTERDAM

He who cannot master the sea
is not worthy of the land.

—Dutch proverb

Water was always the very lifeline of Amsterdam, once a small fishing village. The city's existence and development are inextricably bound to the sea and the Amstel. Its fundamental layout was formed in the thirteenth century when the river was dammed and directed along channels that ran to the sea. Cornelis Anthoniszoon, a painter-cartographer and surveyor, is the author of a painting and a woodcut,

a map cited as the earliest known bird's-eye view of a Netherlandish city, dated 1544, which served as a model for the Bast map of 1597. Established in the fourteenth and fifteenth centuries, the city's limits on the earlier map remain until the seventeenth century.

However, it was Antwerp's decline after 1570 that ultimately led to Amsterdam's prosperity. This initiated the golden age of the city, when it became the mercantile and banking center of Europe. Knowledge of Portuguese trading routes added to the city's wealth. In 1607, the town council adopted the plan of the three canals, whose three concentric rings form the nucleus of the city and are visible on all the maps as Amsterdam grew outward to the west, and later to the east. Linked by radial waterways and lined by spacious quays and roadways, with provision for gardens at the rear of row houses, these canals still form the core of the central city. Areas outside the defensive moat are not encroached upon until the late nineteenth century, except for industry and windmills. When the Zuider Zee began to silt up in the 1870s, Amsterdam's fortunes sunk alongside.

From 1902 to 1915, architect Hendrik Berlage worked on plans to extend Amsterdam south. Scientific surveys led to innovative housing, the formation of new districts, and the provision for parks. Architects Jacob Bakema and Johannes van der Broek continued further expansions to the east in 1965.[36]

Always, in Amsterdam, one is aware of the collective action of the populace, the relation between the public governance and private enterprise. Social responsibility, enlightened regulations, an ingrained respect for the land, and an innate tendency to conserve resources characterize the world's most densely populated country. These factors have led the municipality to act in the interests of the community, contributing to the uniqueness of the Dutch psyche and, consequently, to Dutch planning.

LONDON

[dedicated] To the Metropolis of Great Britain, the most renowned and late flourishing City of London.… You, who are to stand a wonder to all years and ages, and who have built yourselves an immortal monument on your own ruins. You are now a Phoenix in her ashes, and as far as humanity can approach, a great emblem of the suffering Deity…

—John Dryden, *Annus Mirabilis; The Year of Wonders, 1666: A Historical Poem,* 1667

The growth of London, hub of business and trade in Roman times, was dynamic, speculative, and largely unregulated from the outset. Efforts to control development are apparent in the late sixteenth century and were renewed after the Great Fire of 1666. New municipal edicts and a proclamation by Charles II formulated a program for rebuilding and future fire prevention, and despite efforts by Wren, Hooke, Evelyn, and others to create a coherent plan, the city was rebuilt on existing street and property lines, although some urban improvements did occur.

John Rocque's plan, ca. 1745, was based on a careful survey of the city; it shows the different districts, the roads (including the New Road to the north), the institutions, and the open spaces of the metropolis. Although London is punctuated by open spaces—private as well as public places—the street network remains labyrinthine. London, as surveyed by Rocque, has been viewed as a "hinge to the modern world."[37] Only in the early nineteenth century, with the development of Regent Street (the "triumphal way" from the royal place to the newly developed area around Regent Park) is there any attempt to create a coherent vista amidst the urban chaos. London's difficulty lay in having had too many little plans: "Each estate was dealt with as if it were an autonomous village."[38] In the

words of G. K. Chesterton, "London is the most difficult city in the world to fathom. Paris is an explanation. London is a riddle."

The least urban of metropolitan European cities, London grew outward to the north, south, and west. Density remained relatively low as greater London expanded, with seemingly endless row houses whose dreary street fronts occasionally masked treasured rear gardens, sometimes contrary to our images of the city known from Doré's engravings or Dickens's novels.

Following the destruction by bombing in World War II of much of the East End around St. Paul's Cathedral, London missed the opportunity to rebuild a more coherently planned city. Functionalism was the order of the day, and hastily built commercial and residential developments were inserted into the urban fabric with little regard for the immediate environment. Today, high-tech architecture uses site limitations to create imaginative forms and enhance older contexts. The plan of the London underground and its recapitulation in the Tate Art Gallery poster imparts a remarkable order to the state of disorder that is the reality of the urban fabric. Cited as "perhaps the single most iconic and identifiable symbol of London," the original underground map, designed in 1931, was heralded as an example of international-style modernity, its clarity in design reinforced by its sans serif font.[39]

NEW YORK

... there is the city in the shape of New Amsterdam, known also as New York, crammed with towers of glass and steel on an oblong island between two rivers, with streets like deep canals, all of them straight, except Broadway.

—Italo Calvino, *Invisible Cities,* 1972

Founded by the Dutch in 1624, New Amsterdam resisted proposed plans by the West India Company. Fortifications and the defensive wall, today's Wall Street, are recognizable in early maps. Transatlantic communication was frequent. In the *Duke's Plan* of New York, 1664, pictorial detail is shown on a ground plan true to scale. Such landmarks as the Battery and the town wall are easily discernible. Gaps created by water are filled with images of Poseidon and sailing ships.

New York's prominence was born at the beginning of the American Revolution, when it was the leading city, and later as state capital (1789–97) and national capital (1789–90). Increase in growth came with the turn of the nineteenth century and with it a subsequent rise in land and property values. To deal with this expansion, the city sponsored the Commissioners' Plan in 1811. Few urban designs have had a greater impact on a city's growth. Here is an early manifestation of the great American grid (used with far more imagination in the James Oglethorpe plan for Savannah, Georgia, in 1734). Economics triumphed over aesthetics in the New York plan, which was controversial from the start. Although the grid was practical, it was criticized for its denial of topographical conditions, the lack of open spaces, and the resultant monotony.

Proximity to the sea and rivers soon vanished with unprecedented development, and it is in this context that Frederick Law Olmsted and Calvert Vaux's plan for Central Park in 1858 deserves unbounded praise. Propelled by an almost religious veneration of nature, Olmsted created the urban oasis that remains today as the heart and lungs of the city. Surely one of the densest islands in the world, its solid rock foundations later encouraged the building of the skyscrapers. As land vanishes, the irregular southern part of the island, Battery Park, and the World Trade Center today extend to the Hudson River.

Bachmann's "bird's-eye view of Manhattan island and its environs seen from the south," in a color lithograph dated 1859, was made on the eve of the Civil War. This map of the city within an orb, viewed from a fish-eye lens perspective— perpetuating an older tradition ranging from Jerusalem as center of the world or Rome within a perfect circle—reflects the idea of the city as the locus of cosmic harmony, of a microcosm within

the macrocosm, as a sign of perfection. Replete with new cultural implications, this format was revived in the nineteenth century in photographic panoramas. Thus, Bachmann's view has been interpreted as suggesting New York's growing global importance as a metropolis, oddly proleptic of Steinberg's satirical drawing of the city, made in 1976.

BOSTON

...here [at the back of Mr. Hancock's fine house] I enjoyed the finest prospect I have seen in America. All the Bay of Boston with the many Islands, and the Harbour with the shipping and the water round to the Neck, with Boston neck and the fortifications on it; the whole Town lying below and on all sides, and the country on the other side of the Bay and Harbour to a considerable distance.

—Dr. Robert Honyman, *Colonial Panorama,* 21 March 1775

Like New York, the street pattern in early Boston was highly irregular, though it has been suggested that routes followed subtle topographical variations—rocky banks, marshes, and muddy sinks.[40]

Seventeenth- and eighteenth-century maps reveal a peninsula surrounded by water, and the chronological sequence of Boston maps shows a high degree of expediency. Growth followed development and resulted in constant landfill, as is visible from John Bonner's map of 1722, the earliest town plan of an American city. Often reissued and updated, Bonner's map, together with the panoramic view drawn and engraved by Paul Revere,

provide a clear documentation of the layout and vista of the eighteenth-century city. Rivers and swamps and ponds were constantly converted to new land, first the isthmus connecting the city to the south and then, in the mid-nineteenth century, the entire Back Bay with Commonwealth Avenue forming the principal axis of the Emerald Neck-lace, the Boston park system designed by Olmsted.

Created in 1634, the Common was open land designated for common pasture and militia training. Early legislation in 1628 decreed "use zoning" that forbade noxious industries from being based in the city's center. In aerial photos, the irregular pentagon forming the Common and the quadrilateral adjoining Public Garden, initiated in 1824 for recreation purposes, are clearly visible, as is the tree-lined grid of avenues and streets, extending to Massachusetts Avenue, which constitutes the Back Bay.

Representations of Boston contain the smallest and the largest maps in the exhibition. On the cover of *The American Magazine* in 1743, the view of Boston toward Long Wharf from Fort Hill encompasses the entire city. Modeled on a design by William Burgis, the view presents a steepled town with its bustling harbor of sailing ships, while insets feature scenes from the life of native Indians. Dominating the exhibition by virtue of its size, city engineer Henry McIntyre's map of 1852 is known to be the "largest and most detailed single issue map of Boston."

Commissioned by the City Planning Board in 1914, a "map of Boston proper [shows] proposed railroad tunnels and business streets." Traffic in the central business district had deteriorated to such a degree that the municipality sought changes in the infrastructure of the street and rail systems to accommodate increasing public transit lines—on the sites of today's Massachusetts Turnpike and Central Artery. Haley and Steele's recent exhibition (1998) of Boston maps from 1630 to 1900 perfectly characterizes Boston's physiognomy in its title, "Cutting down, filling in, spreading out."

1. See *Oxford English Dictionary,* Oxford, 2d ed., 1989, 20 vols., IX, 348 and XIX, 620. See too Denis Wood, *The Power of Maps,* London, 1993, exhibition brochure (New York: Cooper-Hewitt, 1992–93): "Since every map takes a point of view, it is important to ask whose point of view is this? Whose interest is served by this particular view of the world?"

 For definitions of different kinds of maps, see Harley and Woodward, *Cartography,* xvi, passim. The first volume of a comprehensive history of cartography, it is a fundamental source. See too Harvey, *Topographical Maps,* 9–14; also, Elliot, *City,* 9, who notes three distinct styles, namely, plan, view or plan-view, and bird's-eye view.

2. Monmonier, 1.

3. R. V. Tooley, "Maps in Italian Atlases of the Sixteenth Century," *Imago Mundi* (1939): 12–17.

4. See the writings of J. B. Harley, particularly, "Silences and Secrecy: The Hidden Agenda of Cartography in Early Modern Europe," *Imago Mundi,* 40 (1988): 57–76, esp. 71. Also, M. V. Blakemore and J. B. Harley, "Concepts in the History of Cartography. A Review and a Perspective," *Cartographica,* vol. 17, no. 4 (1980): 7–13.

5. Harvey, 69. For Çatal Hüyük, see Elliot, 10.

6. Ibid., 106, 133–35.

7. O. A. W. Dilke, *Greek and Roman Maps* (Ithaca, N.Y.: Cornell University Press, 1985), 104–06. Cf. Harvey, 130.

8. See Harvey, 84–103, passim, for a discussion of mapping during the Middle Ages. Data cited in this paragraph may be found in monographs of individual Italian cities in the series published by Editori Laterza (Rome and Bari). See also Chiara Frugoni, *A Distant City: Images of Urban Experience in the Medieval World,* trans. Wm. McChaig (Princeton: Princeton University Press, 1991).

9. Elliot, 21–22. Schulz, "Jacopo de' Barbari," 439–41; this is the seminal article on the history of early mapping of cities.

10. See Pinto, 35 and note 2, passim.

11. Elliot, 16. See Hans Wolff, *America, Early Maps of the New World* (Munich: Prestel, 1992), 108.

12. See Pinto, 44, regarding Bufalini's introduction of cross-hatching to delineate topographical variations, thereby anticipating the use of contour lines. Also, Frutaz, vol. I, 168–72; vol. II, 189–221, who notes Bufalini's reconstruction of ancient monuments, and elements from earlier maps—for example, the twenty-four winds in the margins.

13. Lloyd Brown, *The Story of Maps* (New York: Dover Publications, 1949), 172.

14. For French sixteenth- and seventeenth-century maps, see Hilary Ballon, *The Paris of Henri IV* (Cambridge, Mass.: MIT Press, 1991), ch. 6.

15. The artist of this painting is unknown. Now in the collection of the Society of Antiquaries, it was once at Cowdray Hall, Sussex. See reproduction in Eric de Maré, *Wren's London* (London: The Folio Society, 1975), 23, fig. 16.

16. Elliot, 47–50.

17. Ibid., 57, 59.

18. Ibid., 59.

19. Augustyn and Cohen, 70–89; for the Ratzer plan and Ratzer map, see 73–77.

20. Reps, *Urban America,* 154.

21. Augustyn and Cohen, 10–11.

22. For maps of Manhattan, see Augustyn and Cohen, 70–89.

23. Ibid., 80.

24. Harvey, 177.

25. Reps, *Views,* 160.

26. Augustyn and Cohen, 156–57.

27. Branch, *City Planning,* 66–67, 179.

28. See Augustyn and Cohen, 152–53, for a reproduction of this map.

29. John Noble Wilford, *The Mapmakers* (New York: Vintage-Random House, 1981), 350–51.

30. See Augustyn and Cohen, 157–58.

31. Branch, *City Planning,* 76–79. Note the launching on 24 Sept. 1999 of the first commercial satellite, by Space Imaging, with the highest resolution imaging to date (*New York Times* magazine, 5 Sept. 1999; *New York Times,* 13 Oct. 1999).

32. Harley, "Maps," 284.

33. Frutaz, vol. I, 148, 151–55; vol. II, 167–69.

34. See Edmund Bacon, 159–60.

35. "Roma Interrotta," *Architectural Design,* vol. 49, nos. 3–4, 1979, Michael Graves, guest editor.

36. See *Amsterdam Architecture, A Guide,* ed. G. Kemme (Amsterdam: Thoth, 1995).

37. Niles Ogborn, *Spaces of Modernity. London's Geographies 1680–1780* (New York and London: The Guilford Press, 1998), 28–38.

38. Donald Olsen, *Town Planning in London* (New Haven and London: Yale University Press, 1964), 5.

39. Edwin Heathcote, "Gems of the Jubilee Line," *Financial Times* (1–2 May 1999), vi.

40. Reps, *Urban America,* 140.

The bibliography on city maps is limited, but expanding rapidly. As evidence, a course entitled Cartographic Fictions at Harvard University, in summer 1999, demonstrated how postmodern theoretical discourse in literary and cultural studies uses the art of mapmaking as a basic paradigm to include the entire realm of human experience.

Herewith, are cited important general references, most of which are English-language publications of the past two decades. Of course, this literature is based on earlier precedents and foreign-language studies as well. More specific references are incorporated in the catalogue entries. Also, note that books on cartography and mapmaking, guide books, travel literature, and, with few exceptions, books on urban history and design are omitted.

Augustyn, Robert T., and Paul E. Cohen. *Manhattan in Maps 1527–1995.* New York: Rizzoli International Publications, Inc., 1997.

Bacon, Edmund N. *Design of Cities.* Harmondsworth, England/New York: Penguin Books, 1969.

Benevolo, Leonardo. *The City in History,* trans. G. Culverwell. Cambridge, Mass.: MIT Press, 1980.

Branch, Melville C. *An Atlas of Rare City Maps. Comparative Urban Design 1830–1942.* New York: Princeton Architectural Press, rpt. 1997.

————. *City Planning and Aerial Information.* Cambridge, Mass.: Harvard University Press, 1971.

Braun, Georg, and Frans Hogenberg. *Civitates Orbis Terrarum.* Cologne: Georg Braun and Frans Hogenberg, 6 vols., 1572–1617 (facs.). Introduction by R. A. Skelton, 3 vols., Amsterdam: Barenreiter-Verlag, 1966.

Buisseret, David, ed. *Envisioning the City: Six Studies in Urban Cartography.* Chicago: University of Chicago Press, 1998.

Campbell, Tony. *The Earliest Printed Maps, 1472–1500.* Berkeley and Los Angeles: University of California Press, 1987.

Cosgrove, Denis, ed. *Mappings.* London: Reaktion Books, 1999.

Elliot, James. *The City in Maps: Urban Mapping to 1900.* London: The British Library, 1987.

Frutaz, A. P., *Le Piante di Roma,* 3 vols., Rome: Istituto di Studi Romani, 1962.

Harley, J. B. "Maps, Knowledge, and Power," in *The Iconography of Landscape,* eds. D. Cosgrove and S. Daniels. Cambridge and New York: Cambridge University Press, 1988, 277–312.

Harley, J. B., and David Woodward. *The History of Cartography.* Chicago and London: University of Chicago Press, 1987, vol. I.

Harvey, P. D. A. *The History of Topographical Maps: Symbols, Pictures, and Surveys.* London: Thames and Hudson, 1980.

Jacob, Christian. *L'Empire des cartes. Approche théoretique de la cartographie à travers l'histoire.* Paris: Bibliothèque Albin Michel, 1992.

Krieger, Alex, and David Cobb, with Amy Turner, eds., *Mapping Boston.* Cambridge, Mass.: MIT Press, 1999.

Monmonier, Mark. *How to Lie with Maps.* Chicago and London: University of Chicago Press, 1996 (ed., 1991).

Morris, A. E. J. *History of Urban Forms before the Industrial Revolutions.* New York: John Wiley and Sons, 2d ed., 1979.

Nuti, Lucia. *Ritratti di città. Visione e memoria tra medioevo e settecento.* Venice: Marsilio, 1996.

Pinto, John. "Origins and Development of the Ichnographic City Plan," *Journal of the Society of Architectural Historians* 35, 1976: 35–50.

Reps, John. *The Making of Urban America: A History of City Planning in the United States.* Princeton: Princeton University Press, 1965.

————. *Views and Viewmakers of Urban America.* Columbia, Missouri: University of Missouri Press, 1984.

Schulz, Juergen. "Jacopo de' Barbari's View of Venice: Map Making, City Views and Moralized Geography Before the Year 1500," *Art Bulletin* 60 (1978): 425–74.

Thrower, Norman, J. W. *Maps and Civilization. Cartography in Culture and Society.* Chicago and London: University of Chicago Press, 1996.

Tooley, R. V. *Maps and Map-Makers,* London: Dorset Press, 6th ed., 1978.

Wood, Denis. *The Power of Maps.* New York: Guilford, 1992.

Woodward, David, ed. *Art and Cartography: Six Essays.* Chicago and London: University of Chicago Press, 1987.

Note the following essential sources:

Imago Mundi. The International Journal for the History of Cartography. Annual.

Digital resources: Maplist, an electronic forum for the history of cartography; includes specific Web sites.

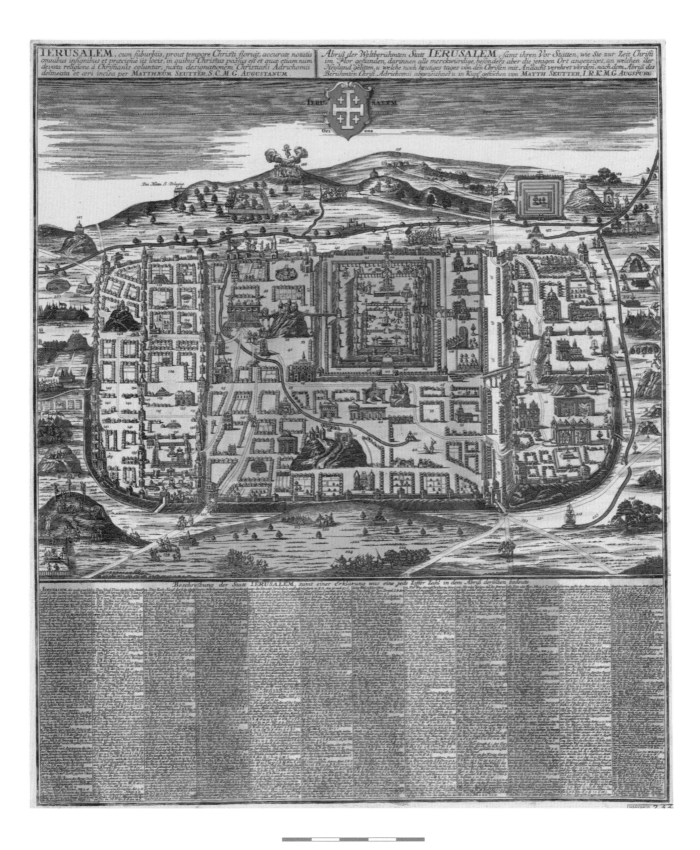

Plate 1

Matthaeus Seutter, *Jerusalem, cum suburbiis prout tempore Christi floruit…*
1745, Harvard Map Collection

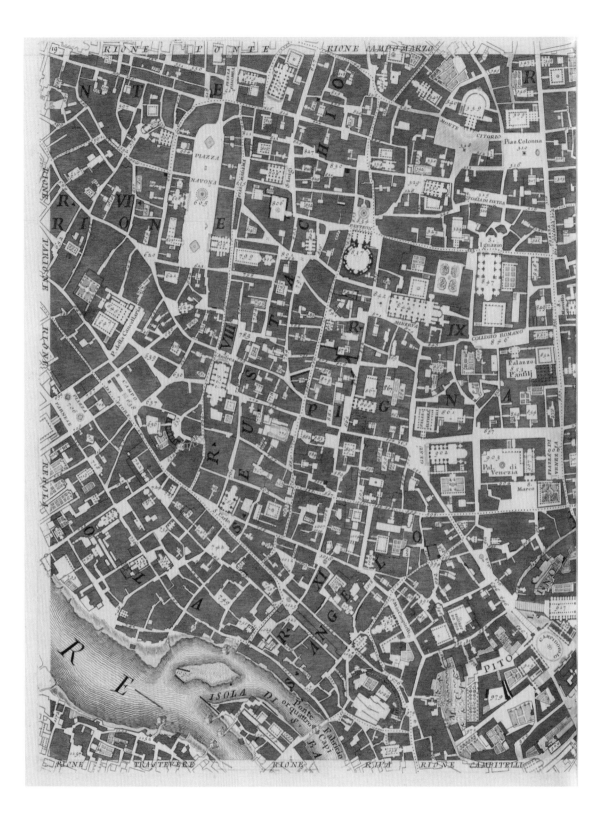

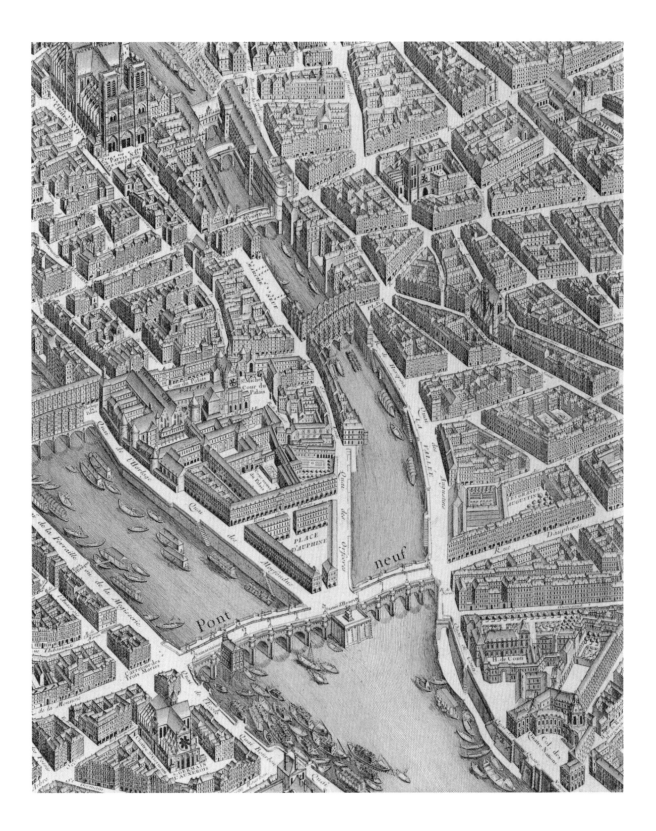

PLATE 3

Commissioned by Michel-Etienne Turgot, *Le Plan de Paris en 20 Planches*
Paris au XIIIe siècle, 1734–39, Harvard Map Collection

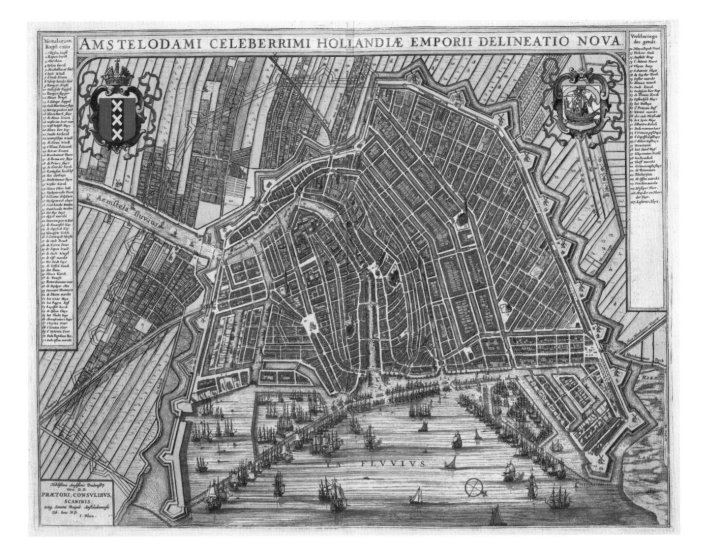

PLATE 4

Joan Blaeu, *View of Amsterdam*, from the *Toonneel der steden van de Vereenighde Nederlanden, met hare beschrijvingen (Townbook of Amsterdam)*, 1649, Library of Congress

PLATE 5

David Booth, *The Tate Gallery by Tube, Map of the London Underground,*
one of a series of new paintings commissioned by
the London Underground Limited, 1987, London Transport Museum

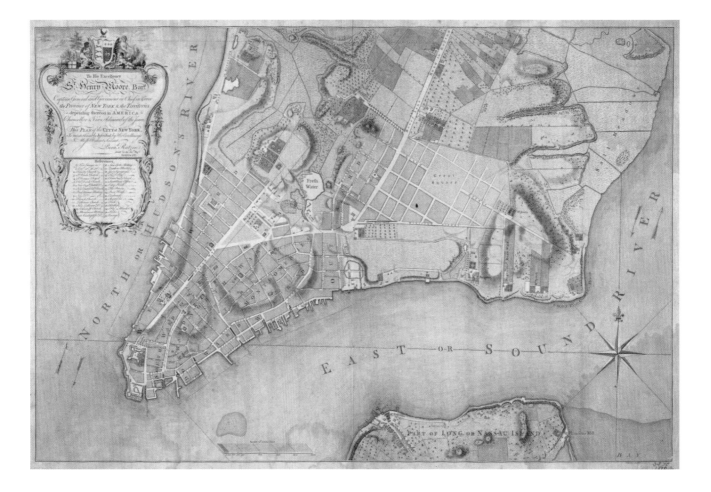

PLATE 6

Bernard Ratzer, *Plan of the City of New York,*
1770, Harvard Map Collection

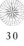

AXONOMETRIC PROJECTION: A three-dimensional form of representation, with vertical lines drawn vertically and horizontals at unequal angles to the base.

BIRD'S-EYE VIEW: A view from a high oblique angle, as if seen by a bird in flight.

CARTOGRAPHY: The art, science, and technology of making maps, together with their study as scientific documents and works of art.

CARTOUCHE: A scroll-like tablet, or ornamental frame, used to provide space for an inscription.

ICHNOGRAPHIC PLAN: Ground plan in which every building and street is delineated in outline. All topographical features are drawn on a single horizontal plane.

ISOMETRIC: Applied to a method of projection or perspective in which the plane of projection is equally inclined to the three principal axes or the object so that all dimensions parallel to those axes are represented in their actual proportions; of equal measure or dimensions.

ISOMETRIC DIAGRAM: Of equal measure or dimensions; applied to a method of drawing to show a drawing of a three-dimensional body related to three axes. The dimensions parallel to the axes are true to scale, and one of the axes is usually vertical. A building in three dimensions. Horizontals are at an equal angle to the base of the drawing, while vertical lines remain vertical.

MAP: A graphic representation that facilitates a spatial understanding of things, concepts, conditions, processes, or events in the human world.

PANORAMA: A picture or a landscape that presents a continuous view of the whole surrounding region.

PERSPECTIVE: A method of representing three-dimensional objects on a two-dimensional surface. In true perspective, the more distant the object, the smaller it will appear. Depth may be rendered by linear or atmospheric perspective.

PLAN: A drawing, sketch, or diagram of any object, made by projection upon a flat surface, usually a horizontal plane. A map of a comparatively small district or region, as a town, drawn on a relatively large scale and with considerable detail.

PLAN-VIEW: A map in which the true ground plan is preserved, but which features some or all of the buildings in elevation.

REMOTE SENSING: Any technique in which images of the earth's surface are made from the air; in mapping the data sent back to earth from orbiting LANDSAT satellites, sensitive to electromagnetic energy.

SCALE: A set or series of graduations used for measuring distances, the equally divided line of a map, chart, or plan that indicates its scale. The proportions used in determining the relationship of a representation to that which it represents.

TOPOGRAPHY: The science or practice of describing a particular place, city, town, manor, parish, or tract of land; the accurate and detailed delineation and description of any locality.

TOPOGRAPHICAL MAP: A general map of large or medium scale showing the shape and pattern of landscape in a tiny portion of the earth's surface.

TRIANGULATION: The tracing and measurement of a series or network of triangles in order to survey and map out a territory or region. A method of surveying based on a simple geometric principle: If you know one side and two angles of a triangle, you can determine the properties of the rest of the triangle.

VIEW: A prospect or vista.

The principal sources consulted for this glossary are:

Harley, J. B. and David Woodward. *The History of Cartography.* Chicago and London: University of Chicago Press, 1987, vol. 1.

Oxford English Dictionary, 2nd ed., Oxford: Oxford University Press, 1989, 20 volumes.

Robinson, Arthur H., et. al. *Elements of Cartography.* New York: John Wiley and Sons, 1984.

Catalogue Entries

JERUSALEM:
THE INTEGRATION OF THREE RELIGIONS IN ONE CITY

William Blake waxed eloquent about the city. Mark Twain declared it a backwater town that not even the most devout pilgrim would visit. Jerusalem's prominence is due neither to its architecture nor its role in the economics and politics of the region, but rather to its sacred sites, venerated by the three major Western religions. For centuries, Jerusalem has been home to Jews, Christians, and Muslims, each contributing to its complex history. Given its legacy as a site of pilgrimage, the number of maps that have been produced of the city is hardly surprising. Through these maps, we may understand the various perceptions of Jerusalem by foreigners, pilgrims, Crusaders, or rulers. The maps chosen here range from the early sixteenth century to the present day. We see maps designed for the use of Christians, and maps that range from ordnance surveys done by the British during the Mandate to a modern satellite image. Each map reflects not only changes in Jerusalem, but changes in the aims and ideologies of mapping this particular city, and advances in cartography.

Although the times of occupation vary, Jerusalem has known many invaders since 1500. Until 1517, when the Turks conquered the city, Jerusalem was in the hands of the Mameluke dynasty, whose rule spread throughout the western section of the Middle East. Maps of Jerusalem from the sixteenth to the eighteenth centuries were dominated by Christian themes, often showing the city in the time of Christ or scenes from Christ's life. Jerusalem was considered an unimportant town, a ghost town in pilgrim literature.[1] Building and development were minimal until the middle of the nineteenth century, at which time Jerusalem began to develop, with foreign consulates (such as the British, French, and German) and religious missions settling in the city. Businesses based abroad were encouraged to build projects in and around Jerusalem. The city began to spread beyond the walls of the Old City and to grow in population. This can be seen in the Wilson map of 1864 and the Spyridon map of 1930; the latter map shows how much the city had developed in sixty-six years.

In 1917, Jerusalem again changed hands, and came under the governance of the British Empire. The British Mandate lasted until 1948, during which time legislation for building in the city was implemented. Several town plans were created in order to regulate urban growth. In 1948, Jerusalem came under control of the newly founded state of Israel.[2] The political status of Jerusalem changed, as the city was partitioned between Israel and Jordan. This division caused the two parts of Jerusalem to expand at different rates and in different directions. The city as it is seen today came into existence in 1967, when Jerusalem was reunified in the aftermath of the Six-Day War.

The past, present, and future of the people of Jerusalem lie within the buildings, the walls, and, not least, the land itself. The people living in this historic religious city may change in the years ahead. Jerusalem, as it has done in its past, will change right along with them.

—*Jennifer French*

1. Bahat, 67.
2. Ibid., 66–72.

Atkinson, Clarissa W. *Mystic and Pilgrim: The Book and the World of Margery Kempe.* London: Cornell University Press, 1983.

Bahat, Dan. *Carta's Historical Atlas of Jerusalem.* Jerusalem: Carta, 1986.

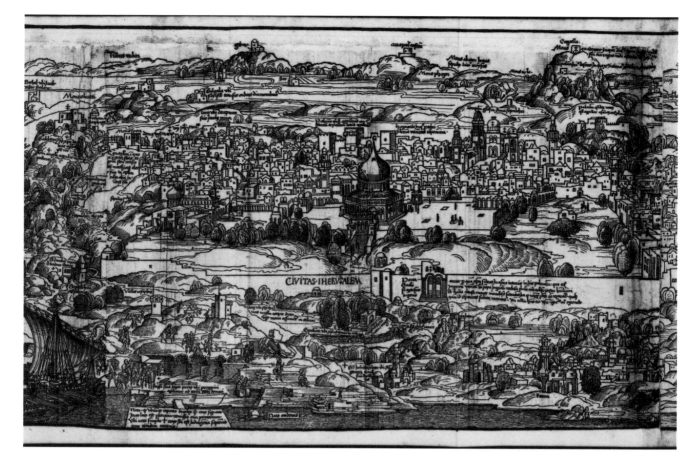

FIGURE 9

Bernhard von Breydenbach, *View of Jerusalem*, detail, from *Peregrinatio in terram sanctam*, 1486, by permission of Houghton Library, Harvard University

Braun, Georg, and Frans Hogenberg. *Civitates Orbis Terrarum.* Amsterdam: Barenreiter–Verlag, 1966.

Campbell, Tony. *The Earliest Printed Maps 1472–1500.* Los Angeles: University of California Press, 1987.

Efrat, Elisha. "British Town Planning Perspectives of Jerusalem in Transition," in *Planning Perspectives,* vol. 8, 1993.

Gilbert, Martin. *Jerusalem History Atlas.* New York: Macmillan, 1977.

Israel Academy of Sciences and Humanities. *Atlas of Jerusalem.* Berlin: William De Gruyter, 1973.

Johns, C. N. *Palestine of the Crusades.* Jaffa: Commissioner for Lands and Surveys, 1983.

Kendall, Henry. *Jerusalem: The City Plan.* London: His Majesty's Stationery Office, 1948.

Levy-Rubin, Milka, and Rehav Rubin. "The Image of the Holy City in Maps and Mapping." In *City of the Great King,* ed. Nitza Rosovsky. Cambridge, Mass.: Harvard University Press, 1996.

Nebenzahl, Kenneth. *Maps of the Bible Lands.* London: Times Books, 1986.

Nuseibeh, Said. *The Dome of the Rock.* New York: Rizzoli, 1996.

Prescott, H. F. M. *Friar Felix at Large: A Fifteenth-Century Pilgrimage to the Holy Land.* New Haven: Yale University Press, 1950.

Riley-Smith, Jonathan Simon Christopher. *The Atlas of the Crusades.* New York: Facts on File, 1991.

Rosenthal, Gabriella. *Jerusalem.* Munich: Doubleday, 1968.

Thurbron, Colin. *Jerusalem.* Amsterdam: Time-Life Books, 1976.

Vilnay, Zev. *The Holy Land in Old Prints and Maps.* Jerusalem: Rubin Mas, 1965.

1. MAP OF PALESTINE AND JERUSALEM

Bernhard von Breydenbach,
from *Peregrinatio in terram sanctam*
Erhard Reuwich, illustrator and publisher
Mainz, 1486
woodcut on three sheets
27 x 127 cm
Houghton Library, Harvard University
Gift of William King Richardson

A woodcut in three blocks, this map depicts a detail of the Holy City within a map of Palestine. Whereas the map presents a panoramic view oriented toward the east, extending from Damascus to Alexandria, the focus is on Jerusalem, which is oriented toward the west, viewed from the Mount of Olives. Sites are designated by Christian names, though the city was then under Muslim rule. The Dome of the Rock (Temple Salomonis) is in the foreground and the Church of the Holy Sepulcher *(Templum gloriosum Domini Sepulchri)* is behind it to the right. It is incredibly detailed in comparison to contemporary maps and shows not only the city itself but also the surrounding landscape. Latin inscriptions identify the major monuments that would have been of interest to learned men and pilgrims.[1]

Cited as the first illustrated travel book, the *Peregrinatio* was conceived by Breydenbach, canon of the Cathedral of Mainz, who enlisted Erhard Reuwich, a painter from Utrecht, to provide a visual documentation to accompany his text of the pilgrimage undertaken in 1483. This map is one of six views of towns enroute, including the celebrated view of Venice. Keen observation is evident in the depiction of topographical features and landmarks as well as sailing vessels, local costumes, and the pilgrims themselves.

1. Campbell, 93–97. See also Nebenzahl, 63–68.

2. HIEROSOLIMA SANCTA DEI CIVITAS

Henry Haestens, printer and publisher
Leyden, 1598
woodcut on six sheets
137 x 107 cm
Harvard Map Collection

This unpublished view of Jerusalem is distinguished by its grand size, fine rendering, and detailed narrative structure. A cartouche reveals that it was printed by Henry Haestens at Leyden, whereas an inscription in French identifies the audience as the Christian reader and the subject as a portrait of Jerusalem in the time of Christ. Scenes of the Passion, Crucifixion, and Redemption coexist with events that occurred in the Old and New Testaments. Further, the source of the map is cited as the "Description of the City of Jerusalem," with its table reproducing the numbers and accompanying legends found on the map. Thus informed, we turn to the Dutch printer, theologian, priest, and rector Christian van Adrichom's famous map of 1584, "Jerusalem and its Surroundings as it Flourished in the Time of Christ," which was disseminated by Braun and Hogenberg in the *Civitates Orbis Terrarum* in 1588. Adrichom's maps, based on events in the Scriptures, the Apocrypha, Josephus, pilgrims' texts, and legends, had little regard for historical time. They also provided an early example of an index system, with 268 place names and a key finder to their location on the map, including the first known depiction of the Fourteen Stations of the Cross.

Comparing the Haestens map with versions such as that of Adrichom, the context of sixteenth-century theology and biblical exegesis suggests sources for the visual representations, namely northern manuscript painting and early Netherlandish art. For example, Hans Memling's altarpieces *Scenes of the Passion* (Turin, 1470) and *Scenes from the Life of the Virgin and Christ* (Munich, 1480) portray several episodes in a single unified space. Parallels are legion between these paintings in their fantastic evocation of biblical dramas

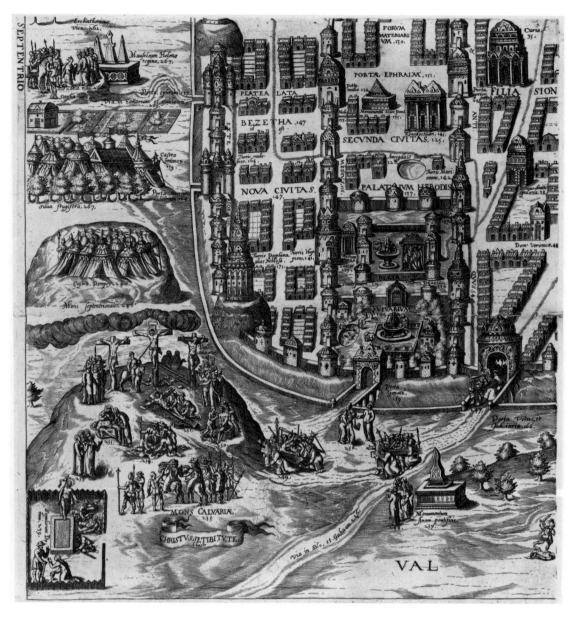

BOSTON UNIVERSITY ART GALLERY

FIGURE 10

Henry Haestens, *Hierosolima Sancta Dei Civitas*, detail, 1598, Harvard Map Collection

drawn from an oblique bird's-eye viewpoint, and the topographical and architectural devices framing the events on the Jerusalem map. Both may constitute an imaginary *Devotio Moderna* to the faithful, a form of spiritual pilgrimage to the Holy Land, whereas to the mapmakers, they present a paradigmatic theater of the world.

3. LA VERA E REALE CITA DI GIERUSALEM COME SI TROVA OGGI

from *Trattato delle piante & immagini de sacri edifizi di Terra Santa, disegnate in Ierusalemme secondo le regole della Prospettiua, & uera misura della lor grandezza dal R.P.F. Bernardino Amico Stampate in Roma e di nuouo ristampate dalli stesso Autore in piu piccola forma, uaggiuntoi la strada dolorosa, & altre figure*

Bernardino Amico, illustrator
Jacques Callot, engraver
P. Cecconcelli, publisher
Florence, 1620
copperplate engraving with etching
19.6 x 28.4 cm
Houghton Library, Harvard University
Gift of Philip Hofer, Class of 1921

Friar Amico's *Treatise on the Plans and Images of the Sacred Edifices of the Holy Land* was the result of a five-year stay in Jerusalem beginning in 1593. As a member of the Friars Minor of the Observant, followers of the Franciscan Ride, Amico executed a series of drawings of the city's shrines. Forty-seven of these were engraved following his return to Italy and published along with a commentary, first in 1609 in Rome and then in 1620 in Florence.

For the plan of Jerusalem that appears as plate 44 in the treatise, Amico relied on a map published in Rome in 1578, drawn by another Franciscan, Antonio de Angelis.[1] A bird's-eye view that depicts the city as seen from the east, it was engraved in this second edition by Jacques Callot. This master French printmaker, here at the beginning of his career, would soon revolutionize the techniques and tools of etching as he vividly chronicled the culture and politics of seventeenth-century Europe. In Callot's plan, the image of Jerusalem has been reduced from de Angelis's two-plate composition to one, presenting the reader with a closer, more immediate view of the city's major monuments—the primary concern of Amico's publication.[2]

Late-sixteenth-century Jerusalem was divided by a variety of religious sects that were engaged in laying conflicting claims to the use of the Holy Places. An unexpected result of the tensions was a newfound interest in the archaeological authentication of sites associated with the Old and New Testaments. Amico's order was particularly emphatic in its role as guardian of the Catholic monuments, and the Christian pilgrims who came to see them. De Angelis, in fact, executed his view of the city as part of his attempts to substantiate the location of the Holy Sepulcher. In addition, the dedication to the Grand Duke of Tuscany that appears in the second edition of Amico's treatise presents the friar's hope that the aristocratic dissemination of his study would act as a plea to free the Holy City

and its sacred monuments from the profanities inflicted on them "at the hands of unbelievers."

De Angelis was recognized as a skilled artist and topographer, and Amico praises his map when he states that it is the "best of those in circulation, presenting the city in its present state." This view of Jerusalem is important cartographically in that it represents the last stages of the centuries-old tradition of amateur artists rendering their own inspired, but often imprecise, documents of cities.[3] The seventeenth century witnessed the professionalization of the mapmaking trade that came to require an advanced knowledge of mathematics as well as the use of complicated instruments. Artistically, however, the Jerusalem published in Amico's work had a rich afterlife, with a copy of the treatise found among Rembrandt's art books.[4]

Rembrandt's interest in the work of Jacques Callot is well documented in the sketches he made after the French artist's work, and is further confirmed by his ownership of the volume.

1. See Alfred Moldovan, "The Lost de Angelis Map of Jerusalem, 1578," *Map Collector* (Sept. 1983): 17–24 for a full analysis of the origins of the maps. I would like to thank David Cobb, Harvard Map Collection, for this reference.

2. The engravings were commissioned and paid for by Christine de Lorraine, the mother of the then Grand Duke of Florence, Cosimo II. See Paulette Chone, David Ternois et al., *Jacques Callot 1592–1635*. Exhibition catalogue (Paris: Editions de la Réunion des musées nationaux, 1992), 180.

3. Yet Callot was clearly following a model handed down to him from the previous century. His future attempts at rendering maps, as in *The Siege of Breda*, 1626, are noteworthy.

4. Rachel Wischnitzer, "Rembrandt, Callot, and Tobias Stimmer," *Art Bulletin* 33 (Sept. 1957): 224–30.

4. Prospectus Sanctae olim et celeberrimae Urbis Hierosolymae

Matthaeus Seutter, engraver and publisher
Augsburg, 1730
copperplate engraving with handcoloring
56 x 63 cm
Harvard Map Collection

Matthaeus Seutter (1678–1757), a major map engraver and publisher in Augsburg, created a map that showed not only the city and its buildings, but also its geographical context. Divided into two

parts, the upper two-thirds is a plan in color of the ancient city after Villalpando. Hills and valleys, once only slight rises and depressions on a map, can clearly be seen in this representation. At the upper right, the coat-of-arms of Augsburg is prominently displayed, while at the upper left, a floriated cartouche bears the following Latin inscription (and German translation): *Prospectus Sanctae olim et celeberrimae Urbis Hierosolymae opera et impensis Mattheai Seutteri S. Caes et Reg. Cath. Maj. Geogr. et Chalcogr. August. Vind.* (Prospect of the once holy and most celebrated city of Jerusalem, the work and publication of Matthaeus Seutter, royal geographer and engraver in Augsburg). A scrolled cartouche at the lower right is color coded; its German title serves as a legend for the forty-seven place names on the map, which range from David's Palace to Christ's tomb.

This map appears to be a conflation of one of Villalpando's maps of Jerusalem and Reuwich's panoramic view. A number of versions exist of the former from 1604. Villalpando was a Spanish Jesuit architect and biblical scholar, known for his reconstruction of Solomon's Temple and Palace based on the description of the temple in Ezekiel's vision, which appears in the lower central portion of the map.[1] Within the circular walls toward the west is the City of David, while Roman fortifications and biblical monuments appear outside the walls.

The lower third consists of a black-and-white bird's-eye panorama of the city and its buildings after M. Mérian.[2] From the Mount of Olives, the city is viewed toward the west, with the mountains round about. In the foreground, we see the Cedron Brook and Josephat Valley, the sixteenth-century walls, with the Golden Gate, the Temple of Solomon, and the Holy Sepulcher in the distance. Seutter has added pictorial elements to his view, including people walking and on horseback near the city gates, and within the city itself. Erroneous details abound; for example, Abraham's tomb near the Fountain of Siloe, and the road to Bethlehem to the north.

1. Juan Bautista Villalpando, *Vera hierosolymae veteris imago a Ioanne Baptista Villalpando,* from *Explanationes in Ezechielis et apparatus urbis ac templi hierosolymitani,* Rome, 1604; see *Jerusalem 3000: Three Millennia of History,* exhibition catalogue, Osher Map Library, University of Southern Maine, April–October 1996, pl. 8, for a later version of Villalpando's map, and text, 28–29.

2. See Eran Laor, *Maps of the Holy Land: A Cartobibliography of Printed Maps 1475–1900* (New York and Amsterdam: A R. Liss, 1986), 164, no. 1131; also 186, for note on Seutter, who produced atlases, most of which were copies of Dutch and French originals.

5. IERUSALEM, CUM SUBURBIIS, PROUT TEMPORE CHRISTI FLORUIT...

Matthaeus Seutter, engraver and publisher
Augsburg, 1745
copperplate engraving with handcoloring
63.7 x 55.5 cm
Harvard Map Collection

This visionary plan of Jerusalem depicts the ancient city at the time of Christ. Like the Haestens map in the exhibition (Leyden, 1598), it is based on the plan of Christian van Adrichom, first published in 1584, together with a small guide describing the 270 illustrated sites.

Born in Holland, Adrichom was a priest, surveyor, humanist, and biblical scholar whose glosses are enriched by references to Josephus, commentaries on the Scriptures, and narratives of pilgrims. Reprinted many times, Adrichom's map served as an authoritative introduction to Jerusalem until the nineteenth century, when it was superseded by maps based on archaeological data and scientific surveys.

Seutter's map represents a copy of Adrichom's original and appears in editions of his *Atlas Novus* (1745?, 1756).[1] Augsburg's coat-of-arms dominates the top center of the map, just above the Mount of Olives. The lower part of the map provides the key to 254 place names and additional sites, identified by letters. Considering the detail of each entry and references to biblical and related texts, Seutter undoubtedly had recourse to Adrichom's *Urbis Hieroslyma Depicta* (Cologne, 1584), an uncompleted history of the Holy Land, which contained his map of Jerusalem.[2]

Set within a quadrangle, the plan provides wonder at every glance, from its marvelous details ranging from the centrally located Temple of Solomon, drawn after Villalpando (where close examination will reveal the Holy of Holies and the guardian cherubim), to the bridge leading from Mount Zion over the city to the temple, to the ravishing miniature-like scenes of calvary, the

BOSTON UNIVERSITY ART GALLERY

palace of Pilate, an Assyrian encampment, imaginary tombs of prophets, fountains and caves, and pilgrims enroute to the gates of the walled city.

Studied together with the *Hierosolymae* map by Scutter of 1730, we may assume that the artist-cartographer's role was primarily that of a disseminator of well-known maps. In these two maps, the artist has provided views, after Villalpando and Adrichom, that illustrate different phases in the sacred history of Jerusalem. The use of similar colors leads one to posit that both maps were executed for a particular atlas, and distribution as separate sheets.

1. See Laor, 164, nos. 1129, 1130; for Adrichomius, see 173.

2. Nebenzahl, 90; pl. 33 reproduces Christian van Adrichom's map, *Cologne*, 1584, as it appears in *Civitates Orbis Terrarum*, vol. 4, Cologne, 1588.

6. JERUSALEM

Ordnance Survey of Jerusalem
Major Charles W. Wilson
Southampton: Ordnance Survey Office
survey, 1864–65; map, 1868
steel engraving
78.5 x 67.5 cm
Harvard Map Collection

Wilson's Ordnance Survey of Jerusalem is the first detailed survey of the city. Executed in 1864–65, it depicts the city then under Turkish rule, enclosed by walls. One of the most accurate maps of Jerusalem, its remarkable precision was based on a "system of triangulation and meticulous measurement." Charles Wilson, Royal Engineer in the British army, led a team that had been sent to Jerusalem in 1864 to make an updated map of the city in order to improve sanitary conditions, especially the water supply. Wilson's description of the cisterns on the Temple Mount is still used today, particularly by archaeologists.

The map is printed in two scales, 1:2,500 and 1:10,000. According to the legend: "The altitudes are given in feet above the level of the Mediterranean…; modern scales (English, French, Russian) are given alongside ancient scales (Roman, Greek, and Egyptian, Hebrew, Babylonian)."[1] Gradations delineate the topography of the city by means of contour lines—wadis and mountains,

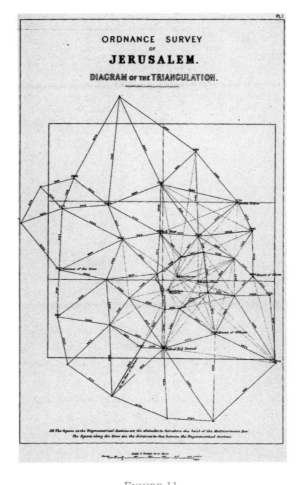

FIGURE 11

Major Charles W. Wilson, *Triangulation Map of Jerusalem*, from *Ordnance Survey of Jerusalem*, 1868, Harvard Map Collection

with isolated structures superimposed, identified as tombs, orphan asylum, sanitarium, and the Byzantine "Convent of the Cross." Unlike earlier maps, there are no pictorial scenes or sweeping landscapes. Fascinating in its topography, the map focuses on the Old City, clearly recognizable with its four divisions into Christian, Armenian, Muslim, and Jewish sectors, and the Temple Mount. Monuments in the City of David are visible to the south, and the Russian property to the northwest. The latter, an example of a foreign enclave set up outside the sixteenth-century wall, is depicted against the terrain of the surrounding hills.[2]

1. Levy-Rubin and Rubin, 378.

2. See Dan Bahat, "The Ordnance Survey and Its Contribution to the Study of Jerusalem," in facsimile edition, Charles W. Wilson, *The Ordnance Survey*, 2 vols. (Jerusalem: Ariel, 1980).

7. JERUSALEM

H. M. King
Goldberg's Press, Jerusalem
1930, copyright S. Spyridon
lithograph
41 x 57.2 cm
Harvard Map Collection

In 1917, the British took over the rule of Jerusalem from the Ottomans. During the ensuing Mandate (1917–48), the British introduced western styles to the city and created several town plans in order to preserve the heritage of Jerusalem, as well as bring it into the twentieth century. Several restrictions in building were implemented during this time, many of which are still applicable today. One of them prevented building in the eastern part of Jerusalem, near the Old City. Building areas would be to the west and south of the city. There is considerable building to the west of the Old City, where the foreign enclaves first resided. Very little construction occurred within the Old City itself, per regulations.[1] This map combines both scientific and artistic aspects of cartography, for its apparent accuracy is evident in the color and architectural details.

The map's legend continues the tradition of Jerusalem as pilgrimage city, beginning with a line from Psalm 122: "I was glad when they said unto me, let us go into the house of the Lord." The key includes the division of seven religious settlements and their institutions. Archaeological interests are manifest in the delineation of ancient walls and sites—the City of David and ancient aqueducts, as well as signs marking the camps of various conquerors, from the Assyrians to the Romans to the Crusaders. To the west we see newly built landmarks, such as the King David Hotel and the YMCA, the latter designed by the architects of the Empire State Building in New York, and until the late 1960s, the tallest structure in the city.

1. For Jerusalem's expansion during the British Mandate, see Bahat, 48–51.

8. JERUSALEM, THE OLD CITY

Henry Kendall
from *Jerusalem, The City Plan: Preservation and Development during the British Mandate 1918–1948*
London: His Majesty's Stationery Office, 1948
F. J. Salmon, Commissioner for Lands and Surveys, Palestine, 1936
86.5 x 70 cm
Mugar Library, Boston University

The title of the map at the upper left is set against a conventional drawing of a walled city, behind which loom domes, spires, and towers. This frame is balanced by the cartouche at the lower right, with its scrolls proclaiming the city's name in English, Greek, Latin, Hebrew, and Arabic. The map's index contains sixty-three sites and twenty-six roads and bazaars, beginning with the Anna Spafford Baby Home and ending with the Via Dolorosa. Much of the Old City remains in its overall plan, its holy places, and its labyrinthine passages, though urban interventions altered large sections of the Jewish quarter, destroyed in the 1948 war.

Kendall's book contains thirty-one maps and diagrams of the earlier planning and improvement schemes that had been proposed under the British Mandate. These include zoning plans, charts for traffic flow, density, and circulation, as well as population distribution data.

The Open Space Plan shows parks and squares in a city deficient in such, largely due to the prohibitive cost of land. Proposals for the creation of public spaces and gardens are given, and current development on Mount Scopus is analyzed in text and photographs. Hence, the commission recommended the restriction of building development to preserve the unique landscape and the architectural aspect of the Old City.

The British attitude toward Jerusalem is succinctly stated in the foreword by the High Commissioner of Palestine:

I write these lines under the shadow of the British withdrawal from Palestine and therefore welcome the opportunity given me to remark on one feature of administration here which has been persistently pursued, without regard to politics or schism, by the selfless devotion of individuals of all races and creeds.

The City of Jerusalem, precious as an emblem of several faiths, a site of spiritual beauty lovingly preserved over the ages by many men's hands, has been in our care as a sacred trust for 30 years. In these pages will be found an important part of the story of the discharge of that trust, of the efforts made to conserve the old while adding the new in keeping with it, of the process of marrying modern progress with treasured antiquity.

Let old Jerusalem stand firm, and new Jerusalem grow in grace! To this fervent prayer I add the hope that the accomplishments and labours of the years covered in this book may be considered worthy to act as an inspiration and an example to the future generations in whose care our Holy City must rest.

9. SATELLITE MAP OF JERUSALEM

The Survey of Israel Society
1972
aerial photograph
65.5 x 73.7 cm
Harvard Map Collection

This aerial photograph of the Old City, from the Mount of Olives looking toward the west, recalls Renaissance ichnographic or contour plan views. Most outstanding is the clarity of the sixteenth-century fortified walls and the six gates providing entry to the Old City. Almost as imposing is the road that rings this historic center, especially the wider segments to the east and north, constructed after the Six-Day War in 1967.

We are struck by the incredible compactness of the city, particularly in the Jewish and Muslim quarters, in contrast to the open garden space in the Islamic landscape of the Temple Mount surrounding the Al-Aqsa Mosque and the Dome of the Rock. The earlier domes of the Holy Sepulcher are visible in the Christian quarter at upper right, and the Armenian Church compound at upper left. In the Jewish quarter, we can detect ruins from the 1948 war, as well as the opening to the Western Wall at the Dung Gate, the excavations in the Nea Byzantine Church and the City of David to the south. The road that circumscribes the Old City is prominent, as is the Rockefeller Institute at lower right, and the parking lots in the west outside the Jaffa Gate, the main entry to the city. A hint of the irregular topography is reflected in the winding road and street network, with Arab housing seen at the lower left, following the contours of the hills.

For centuries, Rome has been called the Eternal City, a title bestowed upon the city as the capital of the Roman Empire, and as the world center of the Roman Catholic Church. According to tradition, Rome was founded by Romulus in 753 B.C. on the Palatine, one of Rome's Seven Hills, the others being the Capitoline, Quirinal, Viminal, Esquiline, Caelian, and Aventine. The Palatine Hill was the site of such imperial structures as the Palace of the Flavians, built by the Roman emperor Domitian, whereas the Capitoline Hill was long the seat of Rome's government. As a result of construction through the ages, most of the Seven Hills are now hardly distinguishable from the adjacent plain. Other hills of Rome include the Pincio and Gianicolo.

Symmetry and geometric design played an important role in the public spaces of ancient Rome. Administrative officials created distinct residential, marketing, recreation, and religious areas throughout the city. Designs for monumental temples, arches, gymnasiums, baths, and forums exemplified a strict regard for symmetry in their separate components. However, the streets did not follow a grid-like pattern, visible in the formal layout of Roman colonies. Rather, Rome resembled a chaotic agglomerate of individually designed systems that interlocked in an "organic" mode.

Today, Rome may be divided into two regions: the inner city, within the Aurelian Wall, built in the late third century A.D. to enclose the area around the Seven Hills, and the sprawling outer city with its suburbs. The historical center is a small area, located almost entirely on the eastern (left) bank of the Tiber river *(Il Tevere)*. The major monuments of Rome's past greatness are located, for the most part, within the ancient historical center. And the street pattern of the city reflects its long and complex history—the Via del Corso traverses *il centro storica* (the historic center) from Piazza Venezia, the geographic center of Rome, to the Piazza del Popolo at the foot of Pincio Hill. Adorning the city and interrupting the dense urban fabric are large open areas such as the Villa Borghese, Villa Gloria, and Villa Doria Pamphili; once private villas, their gardens now serve as public parks.

The emulation of Greco-Roman classicism during the Renaissance revived city-planning efforts along classical lines. In sharp contrast to the narrow, irregular streets of medieval settlements, Renaissance and baroque planning stressed wide, regular radial and circumferential streets, that is, streets forming concentric circles around a central point, with other streets radiating out from that center like spokes of a wheel.

In the mid-nineteenth century, Rome was a quiet city. Not until the city became the capital of a united Italy, in 1871, did feverish growth begin. Whole new quarters were constructed. Early in the twentieth century, the entire area within the ancient walls had been built up, and the city started to expand outward. High embankments were built along the Tiber to prevent floods, as Rome was modernized extensively. The dictatorship of Benito Mussolini (1922–43) was marked by the destruction of old quarters and the construction of such projects as the Via dei Fori Imperiali, Via della Conciliazione in Vatican City, and EUR, designed for Mussolini's international exposition in 1940 (which never was held).

Indeed, Rome has been an urban center for about two thousand years, and although strata of the city's history are still extant, the destructive effects of atmospheric pollution and vibrations from vehicular traffic have risen precipitously since the end of World War II. As a result, efforts toward preservation and conservation are increasing, including restrictions on cars and trucks in the city's historic center. However, as part of preparations for the influx of pilgrims marking the Jubilee in the year 2000, there is a project under consideration to dig an underground artery. This would serve to connect many of the city's restricted areas, which should facilitate the circulation of some ten million expected visitors.

The glory of ancient Rome did not rest on its manifestation of innovative urban design. But

Rome did have impressive sewerage systems and aqueducts that guaranteed potable water and provided efficient means of disposal. Water aided public hygiene, enabling the Romans to erect efficient public institutions such as basilicas and structures for use and leisure, such as markets and baths. Ancient Rome was a collection of complex, separate projects, individually designed, but unplanned on an urban scale.[1]

As Rome witnessed a millennium of decline, from the fall of the Empire in A.D. 476, until its rebuilding by Renaissance popes, there was little concern for city planning. Moreover, during this prolonged period of time, Rome's population declined from approximately 650,000 in A.D. 100 to approximately 17,000 in 1377.[2]

It was not until the fifteenth and sixteenth centuries that Rome was subjected to vast building programs, when the popes from Nicholas V to Sixtus V worked to enhance the city by initiating coherent urban designs. Between 1585 and 1590, Pope Sixtus V, an inspired city planner, developed standardized plans for modular housing, built rows of shops to lure merchants into Rome, renewed the water supply, and connected distant parts of the city in a grid of streets. During this period, also referred to as the Renovation, a system of straight avenues linking the seven great pilgrimage churches of Rome provided views expressive of the power and glory of the Church, attained spatial and aesthetic unity, and facilitated the movement of traffic between different parts of the city.[3]

—*Giorgio Bulgari*

1. Fried, 3.
2. Branch, 68. Population figures vary greatly in different sources, and should be considered as rough estimates. For example, the *Guida d'Italia del Touring Club Italiano Roma e dintorni* (Milan, 1950), 15, 18, notes that Imperial Rome's population stood at more than one million inhabitants in its heyday in the second century A.D., but decreased to a mere 15,000 in the fourteenth century.
3. Ibid. See also Sigfried Gideion, *Space, Time, and Architecture* (Cambridge, Mass.: Harvard University Press, 1962), 75–106.

Borsi, Stefano. *Giovanni Battista Nolli, La Nuova Pianta di Roma, 1748*. Rome: Officina Edizioni, 1994.

Branch, Melville C. *An Atlas of Rare City Maps*. New York: Princeton Architectural Press, 1997.

Elliot, James. *The City in Maps, Urban Mapping since 1900*. London: British Library, 1987.

Fried, Robert C. *Planning the Eternal City, Roman politics and planning since World War II*. New Haven: Yale University Press, 1977.

Frutaz, A. Pietro. *Le Piante di Roma*. 3 vols. Rome: Istituto di Studi Romani, 1962.

Guidoni, Enrico. *L'Urbanistica di Roma tra Miti e Progettii*. Rome and Bari: Editore Laterza, 1990.

Guidoni, Enrico, and Caterina Zanella. *Carte del Centro Storico di Roma, fogli # 29—Piazza Navona; #31—Fontana di Trevi; #38—Campo de Fiori; #39—Largo Argentina; and #40—Piazza Venezia*. Rome: Edizioni Kappa, 1992.

Insolera, Giacomo. *Planimetrie di Roma, Analisi della città dell'universià degli studi di Roma "La Sapienza,"* Rome, 1981.

Lauro, Giacomo. *Splendore dell'Antica e Moderna Roma, a cura di Giovanni Alto*. 4 vols. Rome: Stamparia d'Andrea Fei, 1641.

Lugli, Giuseppe. *Pianta di Roma Antica*, terza ristampa. Rome: Azienda grafica Bardi, 1993.

1. VIEW OF THE CITY OF ROME

anonymous
1491
woodcut
12 x 14.3 cm
Fogg Art Museum, Harvard University Art
Museums, Gift of Philip Hofer

Woodcuts of Italian cities, first published in the *Supplementum Chronicarum* of 1486, contain this panoramic view of Rome, which depicts the famous classical buildings as part of the general urban fabric. At the center, the Pantheon is clearly delineated, as are other well-known monuments throughout, such as the Colosseum, the Dioscuri, and the Castel San Angelo, while the campanile of Old St. Peter's dominates the scene.[1]

Adapted from a painted panorama of the city, ca. 1478–90 (by an unknown artist), this woodcut is the earliest printed view of Rome.[2] Animated by a strong *S*-shaped curve, formed by the city walls as they meet the Tiber, the river flows out into the distant harbor. Enigmatic figures and ruins appear outside the walls near the lower frame, probably summarily quoting earlier works.

The map of Rome appears in a chronicle—a type of historical account popular in medieval and Renaissance incunabula. Here are found compilations of sacred and profane history, often embellished with allusions to contemporary discoveries. The most popular of the genre is Hartmann Schedel's *Weltchronick* (Nuremburg Chronicle) of

1493, which contains a world map and double-page city views, at the same time incorporating biblical narratives and mythological fantasies with new geographical discoveries.[3]

1. See Frutaz, text, vol. 1, 148-49; vol. II, pl. 165.

2. Tony Campbell, *The Earliest Printed Maps 1472–1500* (Los Angeles: University of California Press, 1987), 220. The view of Rome is based on a drawing *in situ*, whereas other towns are drawn from imagination.

3. Ibid., 152–53.

2. URBIS ROMAE TOPOGRAPHIA

Bartolomeo Marliani
Valerio and Luigi Dorico, publishers
Rome, 1588
woodcut
29.5 x 47 cm
Houghton Library, Harvard University

The double-page map of Rome, signed by calligrapher Giovanni Battista Palatino (leaves B2v–B3r) is the largest of twenty-three woodcuts in the tome. The printer Valerio Dorico had reprinted Calvo's *Antiquae urbis Romae cum regionibus simulachrum* in 1532. This third edition was dedicated to King Francis I of France, who probably would have relished the illustrations of Roman statuary and architectural monuments, such as the Laocoon and the Arch of Septimus Severus.

Marliani's map, with scale below in *stadia octo* (according to the Greek measure), focuses on the topography of ancient Rome—the river Tiber, its tributaries, and the main roads, the vias Flaminia, Lata, Tiburtina, Appia, and Aurelia. Most dominant are the hills, whose profiles define the city and occupy much of the map; in terms of area, the Esquiline divided into three major parts by roads is the largest. Major monuments are schematically drawn and clearly labeled—the Pantheon at the center, the tombs of Hadrian and Augustus, the columns of Marcus Aurelius and Trajan, the Colosseum, the Circus Maximus, the circus of Nero, and the rectilinear boundaries of the imperial baths of Diocletian and the Antonines. Prominent at the top of the map is the park, and outside the walls the rubric denotes orientation toward the east. Measurements between places are given at intervals.

Outside the silhouette of the city, the table identifies the abbreviations of the principal sites—for example, A = Arcus, B = basilica, and ARS = Aesculapi (clearly marked on the Tiburtine island).

Marliani's map has been cited as the first ichnographic (ground plan) and orographic (physical description of mountains) depiction of Rome. Frutaz posits a collaboration with Bufalini.[1]

1. Frutaz, vol. I, 56–57; vol. II, pl. 21.

3. ANTIQUAE URBIS ROMAE CUM REGIONIBUS SIMULACHRUM

Fabio Marco Calvo
Valerius Doricus Brixiensis, publisher
Rome, 1532
wood engraving
44 x 58 cm
The New York Public Library,
Spencer Collection, Astor, Lenox,
and Tilden Foundations

Dedicated to Pope Clement VII, this book bears the arms of the pope, the city of Rome, and Cardinal Francesco Medici. The blocks were designed by Calvo and cut by Tolomeo Egnazio for the 1527 edition. This 1532 edition is bound with Vitruvius, *De architectura* of 1521. Calvo, humanist and philologist, was once engaged in translating Vitruvius from the Latin to the vernacular. Earlier, Calvo had worked with Raphael on the archaeology and restoration of ancient Roman monuments ordered by Pope Leo X—surely, the origin of this work.

One of twenty-one wood engravings, the view of Rome presented here shows a circular walled city, oriented with south at the top. All the illustrations are accompanied by explanatory texts. The legend on the opposite page notes the Augustan division of the city into sixteen parts with a gate at each terminus. It reads: *Divus postea Augustus ad sexdecim regiones et portas deduxit. Quod et non nulli principes post eum servaverunt.* The sixteen radii of the map lead to a column at the center, crowned with a warrior supporting a victory figure, titled *Millarium Aureum* (Golden Mean). Each segment that represents a region of the city is identified by a characteristic monument. Calvo adds two regions to the

fourteen extant Augustan districts, the large Campus Martius, and the Vatican.[1] The great variety of monuments—triumphal arch, obelisk, palace, sepulcher, amphitheater, circus, theater, Temple to the Sun and the Moon, victory figure of Venus—appear to be drawn from ancient coins and medieval manuscripts.

Remotely based on Alberti's surveying disc with its forty-eight measures, projected for his mid-fifteenth-century map of Rome (now lost and known only through written accounts) or Leonardo's map of Imola with its sixty-four radii, Calvo's map is highly simplified and schematic. But, like his predecessors, Calvo uses a methodology of "locating and representing the points of a ground by bearings."[2] Since there is no attempt at accuracy in the placement or representation of monuments, this map may be classified as ornamental.

1. See Frutaz, vol. I, 53–54; vol. II, pl. 18.

2. See Joan Gadol, *Leon Battista Alberti* (Chicago and London: University of Chicago Press, 1969), 188.

4. PLAN DU CONCLAVE

anonymous
Quay de l'horloge du Palais
aux 3 Estoilles, publisher
Paris, 1676
engraving
35 x 44.5 cm
Harvard Map Collection

The title of this French engraving may be translated as follows: "Plan of the conclave with all the ceremonies observed at the election of the new pope, caused by the vacant seat of Pope Clement X, who held it for six years. . . ." It further describes the election of Cardinal Altieri, a Roman, to the papacy in 1670, who took the name of Clement X.

In another frame the names of the most eminent cardinals are given along with the cities or countries of their bishops' dioceses. A cartouche displays the Barbarini coat-of-arms.

The central plan shows part of St. Peter's with "the place where the pope gives the benediction," Paul III's chapel, the Royal Staircase, the Sistine Chapel (in which one casts the votes for the new pope), the Borgia apartments, and the papal courts of Leo X, Pius IV, Gregory XIII, and Sixtus V. Particularly striking is a small segment of St. Peter's Colonnade as it meets the forecourt, completed by Bernini in 1665.

Sixteen engravings surrounding the plan begin with the funeral procession of the deceased pope, from Monte Cavallo to the Vatican, and conclude with the submission of the cardinals to the new pope, Innocent XI. In between, scenes depict various phases in the election of the pope, the conclave in the Sistine Chapel, and the new pope borne aloft from the chapel to St. Peter's Cathedral.

5. PROFIL DE LA VILLE DE ROME

Antoine Aveline
ca. 1700
engraving
22.3 x 32.8 cm
Harvard Map Collection

Signed by Aveline with the King's Privilege, 1700, the subtitle of this French engraving reads "Capital of the state of the Church and usual residence of the pope." A fantastic panoramic view appears in the middle of the print. The lower half depicts a pastoral and rustic landscape replete with ruins and cavaliers riding toward town and the Tiber, as well as men on foot, a wagon, a carriage, grazing sheep, and seated observers—perhaps including the artist—in the foreground. Two monuments dominate the skyline: one is the Castel San Angelo with supports upholding a banner; the other is St. Peter's. We lose our bearings as we sight the other monuments, here aligned on one side of the Tiber, designated in the French rubrics, and including S. Carlo al Corso, S. Maria Maggiore, S. Andrea della Valle, Chiesa Nuovo, S. Giovanni Fiorentini, and the Belevedere.

Both the landscape and the cloud formation are superbly rendered, typical of the excellence of royal engraving at the court of Louis XIV.

6. Nuova Pianta di Roma

Giambattista Nolli, cartographer
1748
atlas with twelve engravings
44 x 69 cm each
Harvard Map Collection

This plan of Rome, published at the expense of the Lombard cartographer Giambattista Nolli, in 1748, is a testament to a moment of more rigorous scientific cartography, characterized by a splendid formal presentation.[1] Nolli projects himself into a field of rich experimentation and elaboration, abandoning the perspectival-iconographical views of the sixteenth and seventeenth centuries, and adopting a more systematic, modern approach that has sometimes been used as a model.

The plan is composed of twelve large plates (each 44 x 69 cm), the so-called Imperial format, and Rome is shown partitioned into wards *(rioni)*, together with indexes referring to buildings *(palazzi)*, small firms *(fabriche)*, and vineyards and gardens *(vigne ed orti)*, listing a total of 1,320 places and streets. It is the result of a huge collaborative survey begun in 1736.[2] It is also a clear reference to the exemplary iconographical plan of Rome by Leonardo Bufalini of 1551.[3] In both, remains of ancient monuments are incorporated into later buildings.

The scales, given in ancient Roman, English, French, and Bolognese feet, accompany the modern text, which accentuates the influence of Pope Clemente XII Corsini from Florence, and Pope Benedetto XIV Lambertini from Bologna; the map is dedicated to the latter, inscribed in beautiful Roman letters at the base of a column. Rome, with its 150,000 inhabitants, is portrayed during a stage of slight demographic development. However, the city was still rich with "monumental initiatives," and conscious of its rank as the ecumenical capital of Christianity.[4] This is confirmed in the pictorial elements that frame Nolli's plan, by painter Stefano Pozzi, which include illustrations of the Ancient Forum and the Capitoline Hill.[5] The map is adorned with symbolic vignettes of Rome and the Tiber, ancient monuments, and allegorical figures representing the Church.

Above all, Nolli's masterpiece is an artistic endeavor of exceptional quality, executed in accord with new printing techniques. His plan of Rome is an extraordinary source for studies of Roman topography, as well as a historic document with a powerful visual impact.

1. Borsi, 5. See also Frutaz, text, vol. I, 234–37; vol. III, pls. 396–420.
2. Borsi, 6–7.
3. See Frutaz, vol. III, pl. 420, for Nolli's revised version of Bufalini's plan, which he much admired.
4. Borsi, 6–7.
5. Ibid.

7. Pianta Topografica di Roma Antica, con i principali monumenti ideati nel loro primitivo stato secondo le ultime scoperte e con i frammenti della Marmorea Pianta Capitolina disposti nel suo d'intorno

Luigi Canina
1850
copper engraving
97.5 x 140.3 cm
Harvard Map Collection

Luigi Canina, scholar of classical architecture and archaeology, was the first topographer of Rome to insert the *Pianta Marmorea* (the ancient plan known as the *Forma Urbis Romae,* inscribed in marble between A.D. 203 and 211) into the city's archaeological plan.[1] Fragments of the original from this enormous ancient map, which was drawn to scale, are in the Palazzo Braschi, Rome.

Canina's map is a projection of ancient monuments superimposed on the city's modern plan. Topographical indications are given in Italian but are differentiated according to the period; for example, uppercase Roman letters refer to the ancient monuments, whereas cursive letters indicate the modern structures.[2] Two rubrics on either side of the map list the remaining entries that did not fit on the map itself.

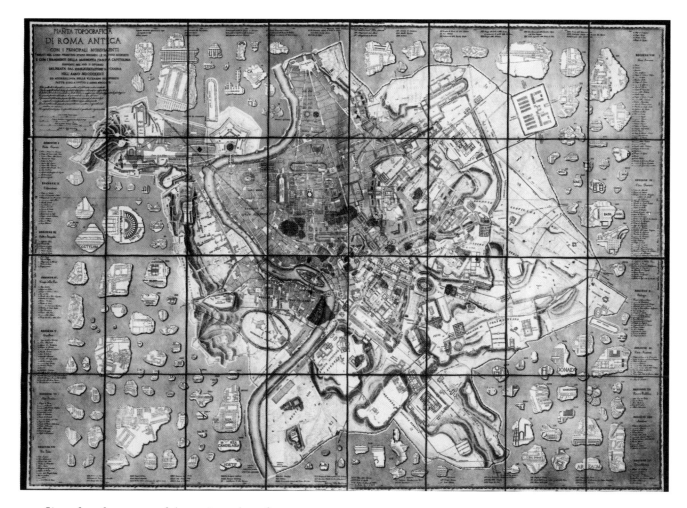

FIGURE 12

Luigi Canina, *Pianta Topografica di Roma Antica . . . ,*
1850, Harvard Map Collection

Sixty-four fragments of the ancient plan of
Rome, dating from the period of Septimus Severus,
adorn the spaces circumscribing the map. These
include such imperial monuments as the Basilica
Ulpia and the markets of Trajan. Descriptions of
each fragment are given in the spaces surrounding
Canina's map, and legends identifying the frag-
ments are listed under fourteen districts. Begun
in 1830, this particular map was published, with
additions, in four editions: 1830, 1832, 1843,
and 1850.

1. Frutaz, vol. I, 92; vol. II, 91–99.
2. Ibid.

8. PIANTA GUIDA DELLA CITTÀ DI ROMA VEDUTA A VOLO D'UCCELLO PUBBLICATA DALLA LITOGRAFIA BULLA

Romolo Bulla
1884–86
chromolithograph
56.2 x 69.5 cm
Harvard Map Collection

This *pianta guida* is a bird's-eye view of Rome done
in 1884–86. Designed by Romolo Bulla, it renders
all the city's major monuments, such as the Colos-
seum, the Pantheon, and St. Peter's, in axonometric
projection. It is an accurate document of Rome's
urban development, and in it one can pinpoint the

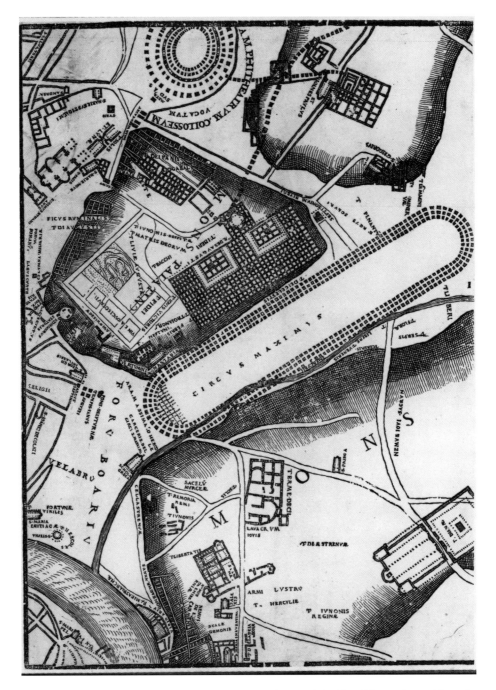

FIGURE 13

Bufalini, *View of Rome,* detail, 1551,
Harvard Map Collection

first settlements of the Prati di Castello district.
Also, we note an indication for the "Alhambra," a
Moorish wooden theater, at the foot of the Ripetta,
the bridge that burned down in the early twentieth
century.[1]

Perspective views of major monuments are
drawn on the plan and identified. In the upper
right, a rubric identifies and provides a key to the
colors used, according to ancient structures, hotels,
churches, theaters, cultivated terrain, buildings in
progress, tramways, districts, and topographical
features. At the lower left, the map's orientation is
indicated in a circle. Aside from the principal pil-
grimage churches, the commemorative columns
are prominent, so too the external city walls and
the recently built railroad station.

1. Frutaz, vol. I, 280, notes this orientation is inexact; vol. III,
 pl. 545.

9. Il Campidoglio

J. H. Aronson
1972
pen and ink on paper
40.6 x 40.6 cm each
Collection of the artist

Using multiple vanishing points comparable to bird's-eye and fish-eye views, and based on contemporary sixteenth-century drawings, Aronson's work shows the Capitoline as it existed before and after Michelangelo's interventions from 1537, executed under the aegis of Pope Paul III. The regularization of the piazza in accord with Renaissance urban planning is evident in these vistas, wherein we witness the transformation from the medieval complex to the bisymmetric axial plan focusing on the equestrian statue of Marcus Aurelius.

Aronson's drawings are part of an aerial study of Rome, and its urban evolution, undertaken by the artist to describe the Italian townscape. He notes that this type of representation is a complete composition in itself, devoid of top, bottom, or sides. With photographs and maps, Aronson has developed a bird's-eye perspective system, wherein the viewer's pleasure may be enhanced by slowly revolving the image in a complete circle.[1] By isolating the view, the artist seems to lock himself within the zone, which appears as an island in space, complete in itself, visible from all angles.

This type of view recalls a panorama of Dresden by Karl A. Richter, taken from the dome of the Frauenkirche in 1824, depicting the city within an orb, a fountain in the center and the Elbe river as a topographical feature.[2]

1. See Edmund Bacon, *Design of Cities* (New York: Penguin Books, 1967), 95, 115, and 118; and reproductions, 114, 119. Also, "View from the Campanile," *Progressive Architecture* (June 1967): 168–69.

2. Frank-Dietrich Jacob, *Historische Stadtansichten* (Leipzig: VEB E. A. Seemann Verlag, 1982), fig. 145.

10. After Calvo's Augustan Rome: Fourteen Equals Sixteen

Gary Hilderbrand
1994–95
ink on paper, pigment, photocopy
30.5 x 29 cm
Collection of the artist

Mr. Hilderbrand is a landscape architect who has always been entranced with maps and plans. He works with these conventions daily as Associate Professor of Landscape Architecture at the Graduate School of Design, Harvard University. But for fourteen months, as a Fellow of the American Academy in Rome, in 1994–95, he became immersed in the topographic and cartographic history of the Roman city and *campagna*. He made his own maps and studied the maps of others: a process of looking, measuring, uncovering, extrapolating, and reconstructing. This is how he came to know Rome, and how he travels back there.

Paris, City of Lights

. . . Paris is in truth an ocean that no line can plumb. You may survey its surface and describe it, but no matter what pains you take with your investigations and recognizances, no matter how numerous and painstaking the toilers in this sea, there will always be lonely and unexplored regions in its depths, caverns unknown, flowers and pearls and monsters of the deep overlooked or forgotten by the divers of literature.

—Honoré de Balzac, *Père Goriot,* 1835

Honoré de Balzac, who strove to document the myriad personalities that make up the human condition in his *Comédie Humaine,* set his stories in the midst of Paris, a city whose grand history trivializes the mundane, though often desperate, situations of his characters. In the minds of many who value the city's art and architecture, Paris has evolved into an organism distinct from its inhabitants. The city, however, is undeniably the product of those who have sculpted it, stone by stone, from the swampy terrain of the Seine valley. The world has acknowledged some of the personalities who have shaped Paris: Henry IV, Louis XIV, Napoleon Bonaparte, Napoleon III, and Haussmann. But most of those who have molded the city, walking her streets and inhabiting her buildings, remain anonymous, surviving only in the marks they made upon their homes.

Although the human element of any urban center may best be left to "the divers of literature," people have, since the earliest days of civilization, been fascinated by mapping—that is, the two-dimensional description of places. The "investigations and recognizances" of explorers have both sated and piqued the curiosity of the world, and introduced its inhabitants to one another. Representing the complexities of any continent, city, or even street has evolved into a discipline as artistic as it is scientific. While cartography has served the ends of human civilization and scientific inquiry, it has also served the whims of kings and companies. In their most common and humble aspect, however, maps have instructed travelers in the task of getting from one point to another. Furthermore, thanks to such elegant and detailed documents as are presented here, many armchair travelers have

accomplished their own "investigations and recognizances" without leaving their libraries. These specimens from the cartographic world range from amateurish, unfinished sketches to masterfully detailed artwork, from imaginative guesswork to precise military mapping. What they all bear in common is the city of Paris, an inexhaustible topic for discussions on history, architecture, urban planning, commerce, social stratification, art, and the totality of the human experience.

Paris's seminal feature has always been her winding river, the Seine. Paris's inhabitants had depended on the Seine for drinking, washing, cooking, and irrigation since the earliest days. Furthermore, river trade was vital in ensuring the financial security and economic power of France's capital, and was honored in the city's emblem of a ship with billowing sails. As a result of these economic factors, the city flourished on the banks of the river. The winding course of the Seine, itself, was the central factor in shaping the city of Paris. With the Ile de la Cité at her core, Paris grew in ever expanding circles, bounded by a series of protective walls. Under Napoleon I and Napoleon III, these walls gave way to the grand boulevards that have subsequently become symbols of the modern city. Today, the peripheral highway acts as a high-speed automotive battlement, partially limiting the outward sprawl that would disfigure the cohesive Parisian elliptical shape.

The very cohesiveness of Paris has created an urban planning dilemma for centuries. On one hand, the oldest and most densely packed neighborhoods, such as Les Halles and St. Michel, are now considered the most historically, socially, and architecturally important. The loss of historic

streets and buildings in those areas at the hands of wrecking crews is bemoaned by some modern critics.[1]

Emperor Napoleon III and Georges Haussmann, however, considered these areas an impediment to transit and development, an eyesore, and a health hazard more akin to rabbit warrens than to quaint remnants of France's great history. While improving sanitary conditions, Haussmann's demolitions may be viewed as pitiless in their disregard of heritage, memory, and the rights of residents; but the axial avenues created from their dust (boulevards de Sébastopol and St. Michel, rue de Rivoli, etc.) are now among the most famous in the world. Their broad pavements mark the beginning of the modern city.

Today the axial planning used by André Le Nôtre has been continued in the design of La Défense, the new development west of Paris begun in the 1960s. The mass of glass-and-steel, international-style skyscrapers and postmodern office buildings lies outside the historic city center, but plays on some of Paris's greatest design elements. The Grand Arch of La Défense (1989) serves as the western terminus of the axis running from the Louvre through the Place de la Concorde, the Champs-Elysées, and the Arc de Triomphe.

—*Olivia Fagerberg*

1. Louis Chevalier, *The Assassination of Paris,* trans. David P. Jordan (Chicago: University of Chicago Press, 1993), 237–45.

Alphand, Adolphe. *Les Promenades de Paris.* Princeton: Princeton Architectural Press, 1984.

Bacon, Edmund N. *Design of Cities.* New York: Viking Press, 1967.

Ballon, Hilary. *The Paris of Henry IV: Architecture and Urbanism.* New York: Architectural History Foundation and MIT Press, 1991.

Bernard, Léon. *The Emerging City: Paris in the Age of Louis XIV.* Durham: Duke University Press, 1979.

Celik, Zeynep, Diane Favro, and Richard Ingersoll, eds. *Streets: Critical Perspectives on Public Space.* Berkeley: University of California Press, 1994.

Christ, Yvan. *Les Métamorphoses de la Banlieue Parisienne.* Paris: Editions André Balland, 1969.

Couperie, Pierre. *Paris through the ages: an illustrated historical atlas of urbanism and architecture.* Trans. Marilyn Low. New York: George Braziller, 1968.

Des Cars, Jean, and Pierre Pinon. *Paris-Haussmann, "Le pari d'Haussmann."* Paris: Edition du Pavillon de l'Arsenal, 1991.

Elliot, James. *The City in Maps: Urban Mapping to 1900.* London: British Library, 1988.

Gabriel, André. *Guide to the Architecture of Monuments in Paris.* Paris: Editions Syros-Alternatives, 1991.

James, Henry. *Parisian Sketches.* Leon Edel and Ilse Dusoir Lind, eds. New York: New York University Press, 1957.

Konvitz, Josef. *Cartography in France, 1660–1848: Science, Engineering, and Statecraft.* Chicago and London: University of Chicago Press, 1987.

Mortimer, Ruth, ed. *Harvard College Library Department of Printing and Graphic Arts: Catalogue of Books and Manuscripts, Part I: French 16th-Century Books*, vol. I, Cambridge, Mass.: Harvard University Press, 1964.

Okey, Thomas. *The Story of Paris.* Nendeln, Liechtenstein: Kraus Reprint, 1971.

Pearl, Joseph, trans. *Caesar's Gallic War.* Woodbury, N.Y.: Barron's, 1962.

Pinkney, David H. *Napoleon III and the Rebuilding of Paris.* Princeton: Princeton University Press, 1958.

Rice, Howard C., Jr. *Thomas Jefferson's Paris.* Princeton: Princeton University Press, 1976.

Sutcliffe, Anthony. *Paris: An Architectural History.* New Haven and London: Yale University Press, 1993.

Trout, Andrew. *City on the Seine: Paris in the Time of Richelieu and Louis XIV.* New York: St. Martin's Press, 1996.

Turner, Jane, et al., eds. *The Dictionary of Art.* 34 vols. New York: Macmillan, 1996.

Van Zanten, David. *Building Paris: Architectural Institutions and the Transformation of the French Capital, 1830–1870.* New York and Melbourne: Cambridge University Press, 1994.

1. PLANTZ, POURTRAITZ ET DESCRIPTIONS DE PLUSIEURS VILLES ET FORTERESSES, TANT DE L'EUROPE, ASIE, & AFRIQUE, QUE DES INDES, ET TERRES NEUVES

Antoine Du Pinet
Jean d'Ogerolles, printer and publisher
Lyons, 1564
woodcut
31.5 x 41 cm
Houghton Library, Harvard University
Gift of Philip Hofer, Class of 1921

Du Pinet produces veritable portraits of cities, their foundations, antiquities, and modes of living, all of which were comparable to the compendiums and world cosmographies that were produced throughout the mid-sixteenth century. Included are twenty-two large woodcut maps on double leaves, whose blocks Jean d'Ogerolles used from

earlier and contemporary sources. Such is the case in the map of Paris, which originally appeared in Guéroult's atlas, *Epitome de la Corographie d'Europe…*, published in Lyon in 1553. Du Pinet stresses the importance of the eye as the receptor of the image. On page xiv, he states that the aim of chorography is "to show only to the eye, in the most lifelike manner possible, the form, the position, and the surroundings of the place painted."

French cartography in the sixteenth century was a largely undeveloped field, owing to a lack of interest and patronage by the Valois kings.[1] Few new large-scale maps were commissioned; and the great European atlases that were translated and copied in France, such as Abraham Ortelius's *Theatrum Orbis Terrarum* and Braun and Hogenberg's *Civitates Orbis Terrarum*, did not appear until the last third of the century. Detailed surveys of Paris had never been made, and the local copperplate engravers' level of skill was low in comparison to that of other European schools.[2]

Guéroult's bird's-eye view of Paris in 1553 is therefore unusual. Based on original woodcuts by Bernard Salomon and published by Guéroult and Arnoullet in Lyon, the plan takes liberties with the Parisian landscape.[3] Oriented with the east at the top, the view places the Seine almost vertically, and near the center of the page, emphasizing the centrality of the Seine, La Cité, and the circularity of the surrounding town. The simplified street plan bears only a vague similarity to actual routes, and, probably for stylistic reasons, streets are depicted as broad, open spaces dividing densely packed residential blocks. This technique aids the viewer in discerning the neighborhoods, although, in actuality, many streets in the old medieval sections were merely narrow, winding passageways. The view's perspective is warped, showing most of the city from a high, western angle, but depicting major buildings, such as the churches of Notre Dame and St.-Germain-des-Prés, and the Palais du Justice, in elevation. Two coats of arms represent the royal fleur-de-lis at left and the municipal emblem of Paris at right.

One of the most famous images of Paris is the tapestry woven between 1569 and 1588,[4] possibly at the abbey of St. Victor in Paris.[5] The original tapestry was destroyed during the Revolution, but copies attest that it was the earliest, most thor-ough, and most esteemed decorative wall map of Paris.[6] Manuscript documents like the Guéroult plan may have been the inspiration for the large-scale views published later in the sixteenth century.

1. Ballon, 212–14.

2. Ibid.

3. Mortimer, 323; see too 233–34.

4. Ballon, 238–39.

5. See the text of Dheulland's *Plan en Perspective,* engraved and published between 1756 and 1766. The plan, which claims to be *"la copie fidele d'un plan gravé de la Bibliothèque de St. Victor. . . . Ce plan est aussi la même que celui qui est représenté sur une tapisserie qui avait autrefois appartenu a la Maison de Guyse . . ."* Dheulland's plan is inserted into the frontispiece of a Louis Bretez atlas of Paris belonging to the Houghton Library, Harvard University.

6. Ballon, 238–39.

2. Vieux Paris et ses Monuments (XVIIe Siècle)

Maison Bouasse-Lebel, publisher
after 1856
engraving with watercolor additions
54.8 x 70.7 cm
Boston Athenaeum

This map of Paris depicts the extant monuments of the seventeenth century as defined by its boundaries under Philip-Augustus, Charles VI, Louis XIII, and the present wall of tollhouses. A note informs the viewer that the buildings still extant in 1856 are followed by an *E;* the others have disappeared or have been reconstructed on a different plan. Thus, the date hypothesized for this map may possibly be based on the presence of the Hôtel de Ville, destroyed in 1871 and rebuilt by 1882. Because the purpose of the map is to present monuments then gone, the buildings are drawn to show their façades in distorted, and inconsistent, perspectival views. Their placement is often arbitrary, omissions are legion, and inaccuracies abound, especially in terms of location. Scale is incoherent and the focus appears to be on monuments since demolished, most during the Revolution. Stress is largely on religious edifices—evidence of a revived Catholic Church, and the gates (thirteen) of the city's successive walls. Note the arched gateways and projecting turrets of the adjacent

Porte St.-Denis and St. Martin to the northeast, and the prominence of the Tower and Porte de Nesle and the Bastille. Most of the monuments are concentrated within the walls built during the reign of Louis XIV (1643–1715). Beyond, one sees the open fields, gardens, meadows, and cultivated areas, including local villages. Markedly absent are the Tuileries and the monuments and urban interventions built during the reigns of Henri IV and Louis XIII, a period of expansion following the Wars of Religion. To the west, the Cours-la-Reine follows the course of the Seine.

Twelve illustrations outside the contour of the newest city walls focus on Gallo-Roman altars and catacombs, medieval tomb slabs, the complex of the Abbaye of St.-Germain-des-Prés in 1370, and the Pump of the Samaritaine, destroyed in 1812. Note too the "druid stones on the terrace of Meudon... the only monument of this kind in the suburbs of Paris."

At the upper right, two legends record the growth of Paris at different eras in terms of area, from the time of Julius Caesar, 56 B.C., to the present walls (of tollhouses). The chart also notes data on streets, roads, gas conduits, and canals that serve sewers. Population figures are given from the time of Philip-Augustus (150,000) to the date of the latest census in 1856 (1,033,262), although different sources cite different figures.

3. PARYS

Frederick de Wit, cartographer and publisher
Amsterdam, 1680
engraving
55.2 x 66.3 cm
Harvard Map Collection

A simulated theatrical curtain frames the engraving, whose upper border proclaims *Parys* in the center of a cartouche between grotesques at its borders and emblems of the fleur-de-lis and the Ship of Paris coat-of-arms hung from the embossed border. A lower panel is inscribed in Dutch, French, German, and English. Twenty-two monuments are indicated, mostly churches, but the Bastille, the Sorbonne, and the Louvre are also included.

Translated from the French, the legend reads: "Paris, capital city of France, called Lutetia by Caesar, is situated on the river Seine. It is divided in three parts—namely, City *(ville)*, University, and Cité—the latter being the noblest, adorned with the Royal Palace. Churches are many in number, of which Notre Dame is the cathedral, having a bishop who commands the spiritual, and a magazine that lacks nothing necessary for war. The City Hall is one of the most outstanding ornaments of the city, built in 1533 by King Francis I."

A bird's-eye panoramic view, the engraving is not unlike seventeenth-century paintings in the north, with foreground trees used as compositional devices. Noblemen on horseback accompanied by dogs indicate a hunting party, whereas shepherds and a rustic hut in a cultivated field dotted with windmills lead across a wide expanse to the townscape and the hills beyond dominated by Montmartre (Mont Marta).

No indication of the three divisions of the city and the river, cited in the rubric, is given; rather, the major monuments appear aligned in an arbitrary sequence from left to right (or west to east) so that the Louvre erroneously appears far to the east of Notre Dame. Most admirable is the technical excellence of the engraving, made particularly manifest in the cloud-filled sky.

4. QUATRIÈME PLAN DE LA VILLE DE PARIS

a copy from the *Traité de la police, ou l'on trouvera l'histoire de son etablissement*
vol. I Nicolas de le Mare, cartographer
A. Coquart, engraver
J. & P. Cot, publisher
Paris, 1705
engraving
57.1 x 80.6 cm
Harvard Map Collection

Nicolas de le Mare's atlas views of historic Paris were compiled in the last years of the reign of Louis XIV, a time in which Renaissance and baroque design principles could be seen throughout Paris and at Versailles. Destruction of the old medieval city had begun, and under the rule of

Henri IV, Louis XIII, and Louis XIV, innovation in the urban design of Paris had flourished. Archaeological revivalism would soon become a major influence in art, as it stimulated curiosity and nostalgia for everything ancient. It was in this environment that le Mare created his atlas.

The second plate in the collection depicts *Lutèce, conquise par les François sur le Romans.* The plan shows a bird's-eye view of the Roman settlement of Lutetia, with the broad expanse of the right bank of the Seine totally bare of structures. The Ile de la Cité is packed with small round houses, and is connected to the north and south banks by two small bridges, each leading to two major roads—part of the Roman cardo linking Lutetia to other Roman outposts. The foreground of the view features a Temple of Isis and a Temple of Apollo, each just off one of the three major roads on the South Bank of the Seine. Already, the two major axes that divide modern Paris into quadrants can be seen in the Roman roads and horizontal arc of the river.

Lutetia (or Lucotecia, a name probably borrowed from the indigenous pre-Celts) was the home of a Gallic tribe known as the Parisii, who had taken advantage of the natural defenses of the island, now named the Ile de la Cité, which lay in the center of a bend in the Seine.[1] The settlement, by virtue of its location, was both defensible and commercially profitable. Fishermen and traders in the rich heartland of western Europe, the Parisii occupied the area through which travelers between the Loire Valley to the south and the northern plains had to pass. Thus, the wooden bridges over the Seine erected and controlled by the Parisii were an additional source of income.

In 52 B.C., the Parisii, led by the Gallic general Camulogenus, burned the town and bridges in a fruitless attempt to repulse the invading Roman legions. Overtaken, the town soon recovered and flourished under the Romans, who built baths, temples, theaters, and a forum, and called the city Lutetia Parisorium.[2]

Le Mare's view of the small village, with almost all construction isolated on the island, represents a very early period in the Roman occupation, since the city soon grew to a population of ten thousand. When rubble walls were built in the late third century A.D., due to barbarian attacks, the city became a military hub. In the fourth century A.D., Emperor Julian chose what was then known as Parisius as his residence. The Romans finally relinquished their hold on Paris in A.D. 497, when the Franks, led by Clovis I, captured the city.[3]

1. See Couperie, chapter 1.

2. Pearl, trans., 265–71.

3. Diane Favro, "Paris, II. Urban Development," in *The Dictionary of Art,* vol. 24, Turner, et al., eds. (New York: Macmillan, 1996), 114–15.

5. PLAN DE LA VILLE ET FAUXBOURGS DE PARIS

from *Mappe Monde Guillaume de l'Isle*
Premier Géographe du Roi
Berer, engraver
Académie Royale des Sciences, publisher
Paris, 1716
engraving
48.9 x 61 cm
Boston Public Library, Rare Book Department

This view of Paris exemplifies the Cartesian love of geometry in French architecture, city planning, and mapmaking that became evident in the late sixteenth and early seventeenth centuries. Under Henri IV, Louis XIII, and Louis XIV, open spaces in geometric shapes began to appear throughout the medieval city, and buildings bordering the new places were standardized.[1] However, these new developments did nothing to remedy the disorder of most Parisian neighborhoods; the places simply stood as monuments to a succession of rulers, as most Parisian construction projects had been—and would continue to be.

This map was commissioned by the Duc de Chartres, soon after the coronation of Louis XV. The cartographer claims to have made "exact astronomic observations" to create the view, and a thick line is drawn crossing the city map through the new observatory built by Claude Perrault in 1672. The building was "equipped with five telescopes, one 130 feet," and was available as a workspace for independent researchers.[2] The observatory was a symbol of Louis XIV's Paris: just as scientists had discovered mathematical alignments between the stars in the sky, so too would Paris be

filled with the harmony of classically aligned axes and geometrically measured maps.

1. Ballon, 251–55.
2. Couperie, ch. 2.

6. LE PLAN DE PARIS EN 20 PLANCHES, PARIS AU XVIIIe SIÈCLE, PLATE II

Commissioned by Michel-Etienne Turgot
Louis Bretez, designer
Claude Lucas, engraver
Paris, 1734–39
engraving
40 x 64 cm
· Harvard Map Collection

The massive atlas commissioned by Michel-Etienne Turgot is indicative of the high level of detail, accuracy, and artistry that urban cartography had reached by the mid-eighteenth century. The atlas consists of twenty plates, plus a foldout overview, all engraved with an astonishing attention to the minutiae of Parisian life. Seen from a bird's-eye view, the plan is the culmination of a five-year survey, during which Louis Bretez was given a special dispensation to enter every building in Paris, in order to sketch the views from numerous points around the city.[1]

The sponsorship of Turgot indicates that the view is officially sanctioned by the highest municipal authority, the Prévôt des Marchands, an office held by him in addition to other titles, such as Conseiller d'Etat. The king appointed each supervisor, who was

> responsible for navigation along the Seine and tributary rivers and commerce in the ports of Paris…and also for sanitation, certain street improvements, [and] administration of royal annuities…As the most ancient of Parisian authorities, they identified themselves with the ceremony, history, and tradition of the capital.[2]

Thus Turgot had good reason for commissioning the huge atlas, which was probably available in individual plates to be mounted as wall decoration, as well as in atlas form; the outer plates all bear segments of an ornamental frame.

We know that the view was distributed gratis to members of Louis XV's court and to all French ambassadors.[3]

Despite the incredible detail achieved by Bretez, the map may have been regarded as less accurate than others created at about the same time.[4] Bretez's design and Claude Lucas's engraving use a pictorial style, in which the boatmen unloading their goods on the banks of the Seine are given almost as much attention as architectural details. Also, the angle of the view required that the width of streets be exaggerated so that the façades of buildings were not obscured. Although these artistic embellishments make for a stunning view of the city, some may have felt that they undermined the geometric perfection of the new Parisian urbanism.

1. Elliott, 55–56.
2. Trout, 5.
3. Elliot, 56.
4. See Guillaume de l'Isle's 1716 plan on the preceding pages.

7. ATLAS ADMINISTRATIF DES 20 ARRONDISSEMENTS DE LA VILLE DE PARIS

M. le Baron G. E. Haussmann, Préfet de la Seine
Antoine Dubois, printer
Paris, 1868
chromolithograph
53.5 x 68.5 cm
Harvard Map Collection

The *Plan Général*, made by the office of the Plan de Paris between 1864 and 1868, is a unique document in the history of urban planning, in that it captures the emergence of modern Paris. Published by Louis Napoleon III's Préfet de la Seine, Georges Eugène Haussmann, the document is the first to depict the grand project undertaken by the emperor and his chief administrator Haussmann, in 1853; the plan shows both completed and incomplete work, including the ring of boulevards, the area of the opera, the great axial thoroughfares of the boulevards St.-Michel, St.-Germain, and Sébastopol, and the swath cut through the center of Paris, the rue de Rivoli.

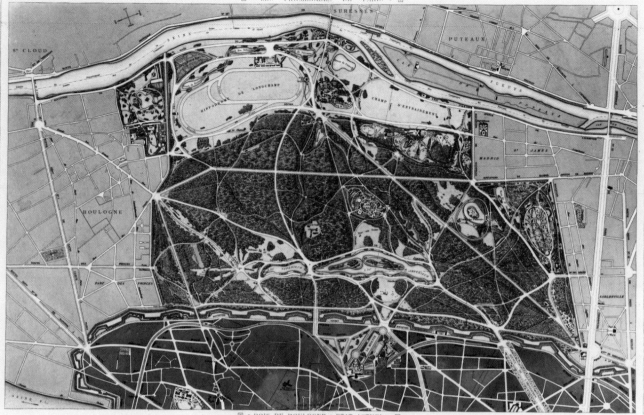

FIGURE 14

Adolphe Alphand, *Les Promenades de Paris, Bois de Boulogne-État Actuel,*
1868, Frances Loeb Library, Graduate School of Design,
Harvard University

The vision of Paris as a major metropolis, based upon classical design principles of geometry and architectural vistas, was cherished by Napoleon and Haussmann. In fact, the *Plan Général* is based upon a map drawn by the emperor's own hand and presented to Haussmann when he assumed the office of Préfet de la Seine in 1853. The massive destruction and building project envisioned by Napoleon III and carried out by Haussmann was truly revolutionary in its approach to urban design, "the first total conceptualization of what we understand by 'the modern city.'"[1] Some aspects of the plan related to the familiar desire of totalitarian rulers to create architectural reference points for their reigns: Napoleon III's ideas were based upon those of Napoleon Bonaparte, whose triumphal arches and grand schemes recall the monumentalism of Imperial Rome. However, Haussmann had also to deal with an entirely new set of conditions,

those required by the rise of the bourgeois class in an age of industrialism. With advances in technology and science, middle-class capitalists wanted affordable, yet elegant housing, adequate business space, wide thoroughfares for speedy transportation, and sanitary residential districts. With these demands grew an entire class of civil servants, including engineers and administrators, who were charged with maintaining the health and economy of the city.[2] Further, they addressed the problem of insalubrious neighborhoods and traffic control. Grand boulevards and monumental vistas were created throughout Paris. The *Plan Général* and accompanying *Atlas* represent the fruition of their plan for a revitalized city.

Haussmann reports that the emperor's original hand-drawn plan, which featured streets and building projects color-coded according to their degree of urgency, was hung on the wall of the office of the Plan de Paris, and was later destroyed in the fire that consumed the Hôtel de Ville in 1871. Napoleon's sketch was the basis for a large and detailed map in twelve sheets (the original burned in the same fire), which was published in atlas form

in 1868 and in later editions, as the *Atlas Administratif des vingt arrondissements de la Ville de Paris,* the *Plan Général* being the first plate in the atlas. The *Plan Général* was also published on a small scale in Adolphe Alphand's *Les Promenades de Paris* (1868), in which the landscape designer summarized his work for Napoleon III.[3]

The map of Paris is rendered in watercolors, which outline past, present, and future construction projects in pink, yellow, and red on a beige background. The succeeding sixteen plates in the atlas cut the city into its twenty arrondissements and provide further detail, including pastel shading to differentiate religious, municipal, public, private, and military areas. Although the *Plan Général* is attractive, its clear, straightforward depiction of Paris obviously has a utilitarian purpose. Small sidestreets and residential areas are largely ignored in order to maintain the focus on the main streets and thoroughfares, where most alterations to commercial and residential buildings were enforced by Haussmann to enhance the street views. In contrast, no detail is spared in depicting Alphand's landscaping projects in the Bois de Boulogne and Bois de Vincennes. The result is a plan that provides both an accurate record of the new construction in the city, and an artistic document that celebrates the emergence of a new order in Paris.

1. Spiro Kostof, "His Majesty the Pick: the Aesthetics of Demolition," in *Streets: Critical Perspectives on Public Space.* Zeynep Celik, ed. (Berkeley: University of California Press, 1994), 11.

2. Ibid., 11–13, 17–19.

3. Van Zanten, 69. Van Zanten cites Haussmann's *Memoires,* I, 15. See note 115.

8. LES PROMENADES DE PARIS
BOIS DE BOULOGNE—ETAT ACTUEL

Adolphe Alphand, cartographer
J. Rothschild, publisher
Paris, 1868
engraving
62 x 90 cm
Frances Loeb Library, Graduate School of Design,
Harvard University

The Bois de Boulogne stands on the western edge of Paris, occupying 2,100 acres of wooded land once part of Rouvray Forest. In the fourteenth century, Louis XI named the area after pilgrims returning from Boulogne sur Mer who petitioned to build a church there. In the seventeenth century, the area around the Longchamp Abbey was a fashionable promenade, and stylish châteaux were built there during the eighteenth century. Much of the area was destroyed during the Revolution and lay unused until Napoleon Bonaparte revitalized the park by reforesting and adding broad, straight lanes for hunting and travel.

When Napoleon III turned his attention to the state-owned Bois de Boulogne in 1848, he deemed it an "arid promenade."[1] It was largely unused by the public except for "duelling and suicides," according to a guidebook.[2] Louis Napoleon, who took a keen interest in landscape design, saw an opportunity to turn the old Bois into an exemplary city park on the model of London's Hyde Park, which he had admired while in exile. The emperor had already instructed his prefect of the Seine, Georges Haussmann, that he wanted small squares and parks throughout the city to improve the health and living conditions of its inhabitants. The Bois de Boulogne was to be the first major park created under the Second Empire, and a lasting monument not only to Louis Napoleon and Haussmann, but also to the park's designer, Adolphe Alphand.

Alphand, an engineer who had worked with Haussmann in Bordeaux, was called to Paris by the prefect in 1854 to head the Service des Promenades and to take control of the landscaping project already underway in the Bois de Boulogne. Napoleon had transferred ownership of the Bois from the national government to the municipality of Paris in 1852, and had hired a gardener named Varé to begin the transformation into a public garden by digging a huge lake, which would be fed by the Seine. It was soon found that Varé had not made any surveying calculations and that his lake "would be dry at one end and overflow at the other," due to the inclination of the land.[3] It was Haussmann's idea to construct instead two smaller lakes on different levels, with a waterfall between, thus forming the Lac Supérieur and the Lac Inférieur. It was at this point that Alphand took control of the project. Within a year, Alphand had completed both lakes, carriageways around them, and lawns. These successes induced the emperor to

authorize the purchase of the adjacent Plain of Longchamp (later to become a famous racetrack) and the Park of Madrid to the north.

By 1858 the park was outfitted with forty-three miles of bridle paths and carriageways, which replaced most of the long, straight roads made by Napoleon Bonaparte. In addition to the two lakes, a system of small ponds, streams, and waterfalls relieved the aridity that the emperor had complained of a decade earlier. The park was furnished with a multitude of service and shelter buildings, as well as ornate fences, lampposts, benches, and other accessories designed by Gabriel Davioud. Approximately 400,000 trees had been planted under the direction of Alphand's chief gardener, Barillet-Deschamps, and even the emperor had helped to stake out the numerous winding footpaths supplied for Parisians' enjoyment.[4]

The motives behind the emperor's improvements in the Bois de Boulogne remain vague. Was he acting on the new urban planning theories that sought to improve the moral and social fabric of the lower classes? Haussmann believed that parks and gardens benefited the public health, especially in view of the rampant cholera and tuberculosis that had exacted a toll in nineteenth-century Paris. Or was Louis Napoleon, in the end, simply providing the city with yet another monument to his own reign? Whatever the personal inspiration, the ensemble of Napoleon III, George Haussmann, and Adolphe Alphand created a Parisian oasis that continues to be one of the most popular attractions in the city.

1. Pinkney, 95.
2. Ibid.
3. Ibid.
4. Ibid., 96.

9. FRANCE
SCALE 1:100,000, PARIS-FONTAINEBLEAU SHEET 10 G

Army Map Service, U.S. Army
Published by the War Office
1944

On Reverse:

ORDINANCE NO.1: CRIMES AND OFFENSES

Military Government—Germany
Supreme Commanders Area of Control
By order of military government
lithograph
91 x 72.6 cm
Perry Casteneda Library
University of Texas, Austin

This huge Paris, all black and warm in the summer night, with a storm of bombers overhead and a storm of snipers in the streets, seems to us more brightly lighted than the City of Lights the whole world used to envy. It is bursting with all the fires of hope and suffering, it has the flame of lucid courage and all the glow, not only of liberation, but of tomorrow's liberty.

—Albert Camus, "The Blood of Freedom," *Combat*, 24 August 1944

When German troops marched under the Arc de Triomphe on 14 June 1940, no shots were fired. Most Parisians had fled when Paris was declared an open city on 11 June; those who remained witnessed the raising of the Nazi swastika over the Eiffel Tower. Despite the fact that no bombs detonated in Paris that day, the violence inflicted by the German invasion was to cast a lingering shadow over the city.

Parisian life in the early stages of the German Occupation was not radically altered. Some who had fled began to return, finding that a curfew was the harshest limitation dictated by the German Commander of Paris. For many, the most punishing aspect of routine existence was the daily parade of a German battalion around the Arc de Triomphe and down the Champs-Elysées. Although the topography of Paris had not changed, a new map of the city was slowly being drawn. The occupying force made its presence known by adopting the most emblematic areas of Paris as its own: the Champs-Elysées and the Place de la Concorde became parade grounds; the Hotel Meurice on the rue de Rivoli opposite the Tuileries was the *Kommandatur* (garrison headquarters); and the Palais du Luxembourg and the Ecole Militaire were made strongholds. Street signs in German directed troops to both German and French sites throughout Paris. Later in the war, German reprisals against increased Resistance activity included stricter measures for citizenry. Men and women were required to carry multiple forms of identification, including work permits, ration cards, and passports, and they faced arrest and deportation if caught without them. This transformation of the City of Lights into a Nazi-controlled police state scarred not only Parisians, but also millions worldwide who carried romanticized memories of Paris. The urban fabric itself had not suffered physical violation, unlike such German targets as London and Warsaw.

Ironically, the majority of physical damage in wartime Paris was sustained during the French insurrection in the last days of German command before the arrival of French and American Allied forces. During the grim street fighting that began on 19 August 1944, Parisians and French Resistance fighters reclaimed their city by occupying the district town halls and erecting barricades against German attacks. The very fabric of Paris—including ancient paving stones, trees planted by Alphand, the public furniture of parks, gardens, and subway stations—was all utilized in establishing the improvised defenses. Some barricades, like the one constructed at the intersection of boulevards St.-Germain and St.-Michel on the Left Bank, referred to as Carrefour de la Mort (Death's Crossroads), became symbols of the courage and ingenuity of the local residents. The Prefecture of Police on the Ile de la Cité, where a stronghold of Resistance fighters was besieged by German forces in the Hôtel de Ville, was destroyed in the fiercest fighting of the insurrection. On 23 August 1944, German commander Dietrich von Choltitz received the order to raze Paris to "a field of ruins," to ensure that the insurrection would not threaten the German position.[1] In preparation for such an order, he had already had all the bridges of the Seine wired with explosives, and filled the Invalides and the crypt of Notre Dame with between two and three tons of explosives each. The Palais du Luxembourg was wired with seven tons of TNT in spite of sabotage attempts by French electricians, and the Eiffel Tower had been mined.[2] The rest of the demolition would be carried out by the Luftwaffe. Despite his readiness, von Choltitz never gave the order that would have leveled the city. Allied forces entered and liberated Paris on 25 August.

From France, Allied forces continued the war against Germany. In less than a year, Germany surrendered unconditionally, on 7 May 1945. The significance of this military topographic map does not lie in its representation of Paris or in its mathematical accuracy. This is, instead, a historical document that, bearing on its reverse an ordinance of the occupying Allied Military Government, testifies to the events of the final year of World War II.

1. The data in this entry is derived from a journalistic account by Larry Collins and Dominique Lapierre, *Is Paris Burning?* (New York: Simon and Schuster, 1965), 207-10.

2. Ibid.

AMSTERDAM AND CIVIC LIFE

Amsterdam in the seventeenth century boasted a liberal religious atmosphere, a relatively free press, an influential school of painting, and the most prolific and technically accurate mapmakers in Europe. Amsterdam's most important cartographers spanned the period between 1540 and 1670, when the city's most ambitious urban plan was put into effect, and human intervention forever changed the landscape.

Living in a region below sea level, the Amsterdammers have always been confronted with environmental factors. The town's earliest inhabitants had to contend with the Great Flood of 1287, which eventually surrounded northern Holland with water on three sides. The thirteenth-century fisherman and traders settled upon the dikes erected along the banks of the river Amstel and the area around the town's dam (thus the name). Because the dikes served as foundations for the streets, which ran at a higher level than the surrounding land, the population developed on the western and eastern sides of the river Amstel, and took on its early *V*-shaped form. By 1481, the city was allowed to build fortifications on its seaside and by the mid-sixteenth century, its borders extended further east and west as *grachts,* or canals, were designed to run parallel to the medieval core of the city.

In the 1540s, artists like Cornelis Anthoniszoon and Antoon van den Wyngaerde began to produce ambitious bird's-eye views of Amsterdam. With Anthoniszoon's map, used as a model for the city's plan in the first urban atlas, the *Civitates Orbis Terrarum,* Dutch cartography began to play a leading role in Europe. Anthoniszoon's plan is fascinating as the earliest known bird's-eye view of a Dutch city, and also because it existed in two forms, one an oil on panel from 1538 and the other a woodcut of 1544.[1] What these two versions imply is the map's dual role as both work of art and useful diagram, aesthetically appealing, yet ultimately practical. The distinctions blur even further when, in the following century, the painter and theorist Samuel Van Hoogstraten writes: "How valuable a

good map is in which one views the world as from another world thanks to the art of drawing."[2] Not least, Vermeer paints contemporary maps as prominent elements in his interiors.

After 1585 and the fall of Antwerp to the Spanish, Amsterdam embarked upon an unprecedented period of growth and economic prosperity. Much of its success in trade and business was the result of an influx of skilled refugees who contributed to vital crafts such as shipbuilding. Along with the influx of new labor, the formation of the Dutch East and West India Companies, ca. 1600, allowed the city to import luxuries and exotica that were the hallmarks of gracious living. One of the results of this exchange of goods was the rise of a resourceful urban bourgeoisie whose needs and cooperation made it possible for the city to organize further land reclamation on a scale that hardly seemed possible just decades earlier.

Generally referred to as the plan of the Three Canals, its major feature was the appearance of three wide canals, the Herengracht, the Keizergracht, and the Prinsengracht. The idea grew out of the collaboration between an architect, a surveyor, and master builder, all members of the city council. Though the plan did not refer to any particular model, it did incorporate contemporary views by dividing the new areas into regular plots that unified the overall appearance of the expanded territory. Also, unlike in most cities, the shape of the extension was formed not by the layout of additional streets, but by the newly emerging waterways. These canals were made to encircle the older *V*-shaped city in a series of angular bends rather than curving lines. This was done so that the newly emerging islands, built from the extracted earth, were of regular size and shape. The intention was to facilitate movement throughout the city both for ships and pedestrians. The landfill on the eastern side of the city was given over to foreigners and the area eventually housed the Portuguese synagogue, as well as the houses of Rembrandt and the philosopher Baruch Spinoza. By the late seventeenth century, the city of Amsterdam was an

artificial archipelago in the sense that almost all of it rested on landfill from the excavated waterways, with an added layer of sand on top. The freshly formed land was subdivided into plots and sold on the open market in accord with a strict zoning scheme. Wooden pilings hammered into the ground supported the vertical load of the new buildings.

The overall achievement of this immense project, spanning most of the seventeenth century, was accompanied by incredible accomplishments in the art of mapmaking. The Dutch had clearly emerged as the dominant cartographers of the period, and many of the best were working in Amsterdam. The Blaeu family, in producing the multivolume *Atlas Major,* for example, was creating the most luxurious atlas yet seen, a type copied by cartographers all over Europe. Blaeu maps are still collected today for their decorative embellishment.

The expansion of the map trade in Amsterdam was due in part to the extensive surveying and mapping needed to carry out this complex urban plan, but other factors also played a role. Dutch explorations in the north, the East Indies, Africa, and America required accurate maps for both captains and merchants. In addition, the long and bitter war with Spain kept many cartographers employed, as the conquest of territory called for a constant surveying of the land. Much of the information the general public received of the military politics came from large volumes that were dedicated to the theater of war, in which the maps of sieges were accompanied by explanatory texts. The artist, cartographer, and publisher Claesz Jansz. Visscher specialized in these military maps. His successful printing house, along with those of Hondius and Jansson, at various times competed and collaborated with that of Blaeu. With no copyright law in place, the imitating and buying of one another's plates was a common occurrence, making the current study of seventeenth-century Dutch atlases a challenge.

The monumental conception of Dutch mapping may be lost in this age of aerial photography and remote sensing, which can encapsulate and put into perspective our town, our region, and our continent. In many ways, the maps produced in Amsterdam at its height were functioning in tandem with the recently invented telescope; instead of bringing what was farther away into closer view, it placed one's city in context within the grand panorama of the known world.[3]

—*Julie Marchenko*

1. *The Dutch Cityscape in the Seventeenth Century and Its Sources.* Exhibition catalogue (Amsterdam Historisch Museum and Art Gallery of Ontario, 1977), cat. no. 22.

2. Alpers, 74.

3. Alpers, 67: "…the map allowed one to see something that was otherwise invisible. Like lenses, maps were referred to as glasses to bring objects before the eye."

Alpers, Svetlana. "The Mapping Impulse in Dutch Art," in *Art and Cartography. Six Historical Essays.* David Woodward, ed. Chicago: University of Chicago Press, 1987, 51–96.

Elliot, James. *The City in Maps. Urban Mapping to 1900.* Exhibition catalogue, London, British Library, 1987.

Gutkind, E. A. *Urban Development in Western Europe: The Netherlands and Great Britain* (International History of City Development, VI). New York: Free Press, 1971.

Heinemeijer, W. F., and M. F. Wagenaar, et al. *Amsterdam in Karten. Verandering van de stad in vier eeuwen cartografie.* Antwerp: Zomer and Keuning, 1987.

Hollstein, F. W. H. *Dutch and Flemish Etchings, Engravings, and Woodcuts, c. 1450-1700,* I. Amsterdam: M. Hertzberger, 1949.

Lakerveld, Carry van, ed. *The Dutch Cityscape in the Seventeenth Century and Its Sources.* Exhibition catalogue, Amsterdam Historisch Museum, 1977.

Lynam, Edward. *The Mapmaker's Art. Essays on the History of Maps.* London: Batchworth Press, 1953.

Murray, John J. *Amsterdam in the Age of Rembrandt.* Norman, Okla.: University of Oklahoma Press, 1967.

Nuti, Lucia N. "The Perspective Plan in the Sixteenth Century: The Invention of a Representational Language," *Art Bulletin* (March 1994): 105–28.

Skelton, R. A. *Decorative Printed Maps of the 15th to the 18th Centuries.* London and New York: Staples Press, 1952.

Vrij, Marijke de. *The World on Paper. A Descriptive Catalogue of Cartographical Material Published in Amsterdam During the Seventeenth Century.* Exhibition catalogue, Amsterdam: Theatrum Orbis Terrarum, 1967.

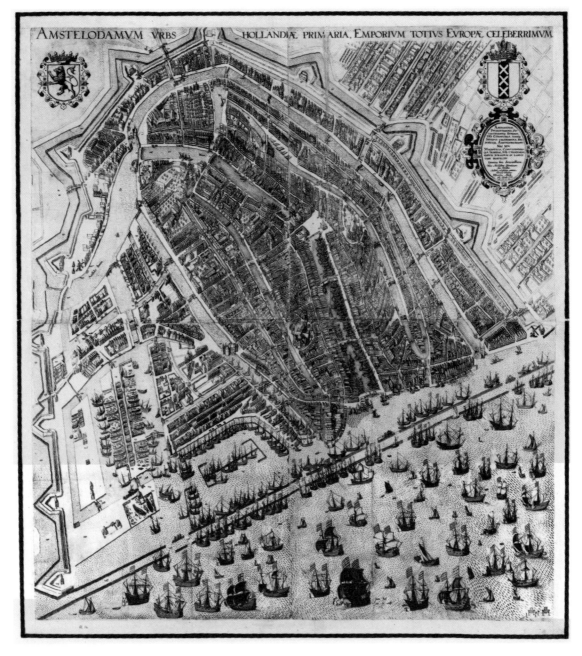

AMSTELODAMVM VRBS HOLLANDIÆ PRIMARIA, EMPORIVM TOTIVS EVROPÆ CELEBERRIMVM

BOSTON UNIVERSITY ART GALLERY

FIGURE 15

Pieter Bast, *Bird's-Eye View of Amsterdam,*
1597, courtesy of the Fogg Art Museum, Harvard University
Art Museums, loan from Robert M. Light. Photo by David Mathews.
Copyright President and Fellows of Harvard College,
Harvard University

1. BIRD'S-EYE VIEW OF AMSTERDAM

Pieter Bast, geographer, engraver, and publisher
Amsterdam, 1597
ink on paper
90.7 x 80.9 cm
Fogg Art Museum, Harvard University Art
Museums, Loan from Robert M. Light

Pieter Bast's work exemplifies the tenuous distinctions between cartographer, artist, printmaker, and publisher in the Netherlands during the sixteenth and seventeenth centuries. Though most of his prints are concerned with landscape in one form or another, they range from panoramic cityscapes to biblical narratives to urban plans such as this one. Unlike the great publishing houses of Visscher, Blaeu, and de Wit, Bast represents the ability of the thriving Dutch printing establishment to support even the smaller ambitions of independent artist-cartographers.

For this plan, Bast probably relied on the 1544 woodcut of Amsterdam by Cornelis Anthonisz. that

includes a small, almost inconspicuous scene of the gallows in the lower right corner of the map.[1] This image of execution was a recurring motif in maps, as it served to warn its primary user, the sailor, of the town's strict moral code and capacity for effecting justice. The 1599 plan depicts the city as it would have appeared before the ambitious seventeenth-century expansion, but the new fortifications that surround the wharves and shipyards on the east side already indicate the city's growth from its mid-sixteenth-century nucleus.

1. Bast may also have looked at the plan of Amsterdam found in the 1572 *Civitates Orbis Terrarum* atlas by Braun and Hogenberg, which itself looks back at the Anthonisz. The use and reuse of earlier maps by succeeding generations of artists, cartographers, and printers was commonplace then and now.

2. VIEW OF AMSTERDAM

from the *Toonneel der Steden van de Vereenighde Nederlanden met hare beschrijvingen,* volume I.
Joan Blaeu
Amsterdam, 1649
engraving
41.9 x 53.9 cm
Library of Congress
When the Blaeu printing house was ready to publish its monumental atlas of Netherlandish city

FIGURE 16

Cornelis Anthoniszoon, *De vermaerde Koopstadt van Amstelredam,* 1544, courtesy of the British Library

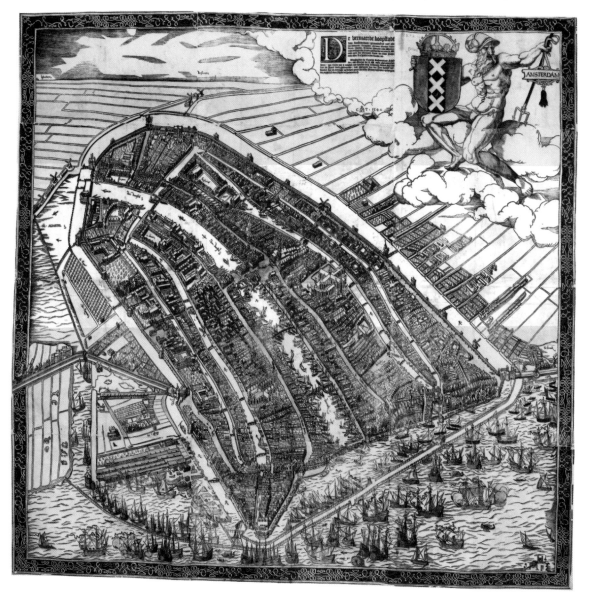

maps and views in 1648, the Dutch and Spanish powers had agreed to a peace by the Treaty of Westphalia, with the Southern Provinces remaining under the Hapsburg crown, and the Northern, including Holland, gaining independence. Blaeu accordingly divided his atlas into two volumes, with the first tome incorporating the twenty-six towns newly captured from the Spanish and recently incorporated into the Northern Netherlands. The plan of Amsterdam appears in the middle of volume I and is accompanied by twenty-two pages of descriptive text, providing the reader with an armchair-travel experience that was first popularized in the *Civitates Orbis Terrarum* by Braun and Hogenberg (1572–1617).

Yet Joan Blaeu was continuing the cartographic tradition established by his father, Willem Janszoon, in 1599. The elder Blaeu, a student of the Danish scientist Tycho Brahe, was an important contributor to the science of mapmaking who was known for incorporating new geographical discoveries into his maps and authoring manuals on the theory of cartography. Willem Blaeu also invented a type of printing press that allowed him to increase dramatically his output, making the Blaeu name synonymous with prolific and accurate mapmaking. In fact, the Blaeu-designed press was so successful that it was transported across the Atlantic on the *Mayflower*.[1]

Like Pieter Bast before him and Johannes de Ram after, Blaeu presents Amsterdam from the point of view of the bustling harbor, an orientation that may be traced to the earliest printed plan of the city in Sebastian Münster's *Cosmographia* (1550). By the time the Blaeu family was operating its highly successful printing shop, Amsterdam was known as a haven for those fleeing religious persecution, as the city systematically incorporated everyone ranging from Flemish refugees to Portuguese Jews. The result was a diverse and tolerant, if segregated urban landscape. Yet at a time when other cities were refusing to print the works of Galileo and Descartes, the presses of Amsterdam were rapidly publishing them.[2] In a city known for its Jewish intellectuals, such as Manasseh ben Israel and the philosopher Spinoza, Amsterdam became the center of the Hebrew book trade.

1. Murray, 114.
2. Ibid., 91–92.

3. AMSTELDAM

Johannes de Ram, engraver and publisher
1690
engraving
82.5 x 97.6 cm
Harvard Map Collection

This elaborate and detailed map exemplifies many precepts of seventeenth-century Dutch cartography, as it is both a technically sophisticated plan of the city reflecting its mercantile dominance and a print meant to be displayed for its aesthetic value. Following the standard of his more famous contemporaries Joan Blaeu and Nicolas Visscher, de Ram frames the plan with a panoply of putti, cartouches, emblems, and allegorical figures. The result is a rich expression of civic pride and baroque opulence. The crest of the city (the Three Xs) appears in both the upper-left corner of the map and the middle-right margin. It is also presented in the emblem that the two putti hold at the upper-right corner, depicting two soldiers standing in a boat decorated with the city's insignia. The shield with rampant lion that appears at the left margin of the print is the heraldic emblem of the dukes of Holland.

The lower portion of the print is dedicated to a figurative representation of the four continents, flanking a profile view of the city from its harbor. This baroque conceit, personifying the continents in feminine form, may be traced back to Cesare Ripa's *Iconologia* (1593). The contoured city view, however, was a tradition mostly confined to northern Europe, and popularized by the navigation books that Dutch and Flemish seafarers depended on beginning in the sixteenth century.[1] De Ram's cityscape, an older custom of representing a city by the silhouette it forms on the horizon, is appended to his relatively scientific bird's-eye view.[2] Appropriately, the artist has crowned the cityscape with a figure of Mercury, ancient god of trade and commerce, to indicate that Amsterdam was the world's

BOSTON UNIVERSITY ART GALLERY

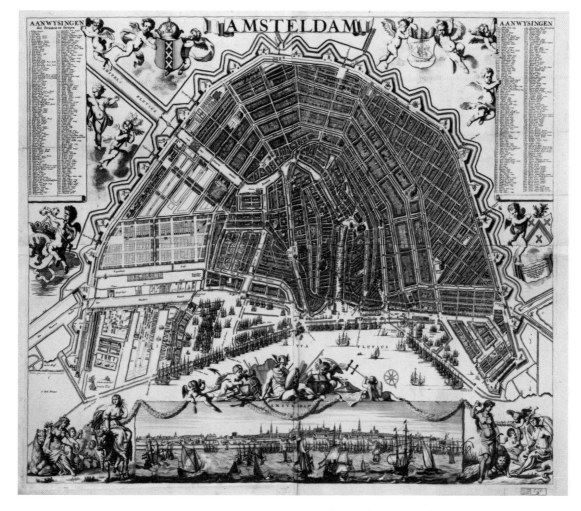

FIGURE 17

Johannes de Ram, *Amsteldam*, 1690,
Harvard Map Collection

economic leader in international exchange and business in the middle of the seventeenth century.

De Ram's map is typical of those displayed in the homes of the city's merchant princes, whose ingenuity and collaboration systematically added more than 1,300 acres to the urban area between the years 1615 and 1672.[3] His plan depicts Amsterdam following the implementation of a much-needed expansion to accommodate the influx of refugees from the conquest of the Southern Netherlands by Spain and the business ventures of a prospering merchant class. Three main canals were built around the historic center, giving the city its distinctive semicircular form and allowing for easier transport of goods. Landfill formed the islands that were then subdivided into plots and sold on the open market.[4] This massive undertaking was an impressive feat of land reclamation, urban design, and engineering. In fact, the citizens were able to take advantage of the abundance of water that they had learned to keep in check when, in 1672, the invading armies of Louis XIV were forced to withdraw due to the opening of the dikes and a flooding of the land.[5] This late-seventeenth-century map captures the last few decades of Amsterdam at its cultural and cartographic apex.

1. See Lucia Nuti, "The Perspective Plan in the Sixteenth Century: The Invention of a Representational Language." *Art Bulletin* (March 1993): 109-110.

2. The cityscape was also a favorite genre of de Ram's contemporaries, such as the painters Pieter Saenredam and Gerrit Berckheyde. The practical production of maps, as well as the artistic interest in depicting native localities, are often interpreted as ideologically linked. See Svetlana Alpers, "The Mapping Impulse in Dutch Art."*Art and Cartography. Six Historical Essays.* David Woodward, ed. (Chicago: University of Chicago Press, 1987), 51–96, esp. 82. For example, she cites the issue of land ownership in the Netherlands as "an important enabling factor in the freedom to map as well as in the freedom to picture the land as in a map."

3. Gutkind, 63.

4. Ibid., 66.

5. Hans Koning, *Amsterdam* (Amsterdam: Time-Life Books, 1977), 46.

4. NIEUWE ACCURATE KAART VAN AMSTELLANDT . . .

Gerrit Drogenham, surveyor
J. Stopendall, engraver
Nicolas Visscher, publisher
Amsterdam, 1730
handcolored engraving
107.6 x 122.2 cm
Harvard Map Collection

Λ large regional view that shows the relationship between Amsterdam and its surrounding countryside, Drogenham's map nonetheless delineates the circular canals that characterize the city. The straightforwardness of this map dispenses with the elegant pictorial language of the preceding century and presents the viewer with a virtually uninterrupted reading of the landscape. As the eighteenth century drew to a close, the Dutch began to lose their supremacy in the field of cartography to the French.[1] Amsterdam itself was occupied by French revolutionary troops in 1795, and with the dissolution of the East India Company four years later, the city entered an economic slump that was only reversed at midcentury with the building of the North Sea Canal.[2]

1. Vrij, 15.

2. Gutkind, 66.

5. HAARLEM, LEIDEN, AND AMSTERDAM

Nicolas Visscher
in *Atlas Mayor/Atlas Novum ad Usum Serenissimi Burgundiae Ducis*
Pierre Mortier, publisher
Amsterdam, seventeenth-century
engraving with hand coloring
55.8 x 83.8 cm
Boston Athenaeum

The Mortier family of map publishers frequently produced composite atlases of this type, in which the work of various cartographers, often previously published, appeared in one volume. The process of buying the plates of one's competitors and predecessors, and collecting them into a "new" or "most accurate" assortment of regional maps, was commonly practiced. Outdated plates were often used to fill out a volume, and Mortier is known to have acquired the stock of various cartographers. It has been suggested that this particular volume is a combination of plates found mainly from two groups. One appears to be a set engraved by Frederick de Wit and known as the *Atlas Maior* (1690) while another was probably from Alexis-Hubert Jaillot's *Atlas François* (1695) which, in a pirated edition by Nicolas de Fer, became known as the *Atlas Royal a l'Usage de Monseigneur Le Duc de Bourgogne.*[1] To complicate the situation even further, the Visscher plate published by Mortier is not found in any of the above publications, and must have been a further addition or perhaps a replacement plate.

Amsterdam, which in 1700 was the fourth most populous city in Europe, appears in relation to Holland's two other major cities, Haarlem and Leiden. All three played a crucial role in the economic and artistic success of the region in the seventeenth century. Noteworthy are the way the cities are indicated by plan instead of perspective—a Dutch innovation that has been linked with the preceding century's need for representing detailed fortifications.[2]

1. I would like to thank Mr. Ashley Boynton-Williams, editor of *Mapforum.com,* for his helpful comments on this atlas.

2. Skelton, 12.

6. A View of Amsterdam

Thomas Jefferys, engraver
illustration from *The Gentleman's Magazine*
17 June 1748, vol. 18, 272
engraving
19 x 41.2 cm
Harvard Map Collection

The year that Jefferys provided this view of Amsterdam for *The Gentleman's Magazine,* the distinguished monthly to which Samuel Johnson regularly contributed, he was appointed chief geographer to the then Prince of Wales, later George III. Jefferys's career was marked by unparalleled success as he became the major producer of maps for the British government in the form of official surveys, atlases, and books. His declaration of bankruptcy in 1766, however, proved how tenuous the cartographer's position really was, as the costs of production overwhelmed him.

A View of Amsterdam was the accompanying illustration to the June 1748 article "Historical Chronicle: Account of the Civil Commotions in Holland. The Prince of Orange's Speech," which reported widespread outbreaks of civil disobedience and violent uprising over the annual gathering of taxes. Part of a larger reform movement that began in Amsterdam, the revolt was a general response to the corrupted rule of the city's regents. The leaders were publicly executed, and Amsterdam would have to wait until the shortlived proclamation of the Dutch Republic in 1795, for a more democratic power structure.

The Gentleman's Magazine often featured maps and city-views, and Jefferys's Amsterdam is yet another example of the ever-popular urban profile tradition in Dutch prints. Yet the artist here has elaborated the view to include vignettes of daily life—on the left bank of the river, he portrays peasants and laborers engaged in the loading and unloading of goods from the nearby boats. In contrast, the right bank of the Amstel is occupied with the quiet leisure of aristocratic living, as well-dressed citizens stroll against the backdrop of a large, noble estate. Whether the engraver was

subtly addressing the class differences that caused so much turmoil in Amsterdam during this period remains unclear, as such images of both toilers and princes were common features of Northern European manuscripts and paintings.

7. An Indication of the Public and Principal Buildings

Cornelis van Baarsel, cartographer
Petrus Nicolai Tuyn, engraver
G. W. Tielkemeijer, publisher
Amsterdam, 1844
chromolithograph on linen
38.1 x 49 cm
Harvard Map Collection

The Dutch, French, and English translations of the legend's text suggest that this map was produced for the tourist trade. Its easy-to-fold linen material and small size made the map a practical reference to the city's major monuments. The plan, produced after the 1825 dredging of the port (due to a build-up of silt), shows the reconnection of the city's harbor to the Zuider Zee by the North-Hollandskanaal, or, as stated for the English reader, the Northlandish Canal. The city was at this time desperately trying to recover from decades of impoverishment caused by the Napoleonic wars. Rampant unemployment was somewhat lessened by the many men required to lay the railways to Haarlem and Utrecht, as well as the building of the main train station on a man-made island (1880s) separating the city from the River Ij. Only a few years after the publication of this map, the city's four-hundred-year-old fortifications were demolished and Amsterdam began to expand into an industrialized, modern metropolis faced with the common concerns of sanitation and public housing.[1]

1. Gutkind, 66.

8. Knowledge: Amsterdam, 1663

Joyce Kozloff
1999
fresco on wood panel
8 x 10 in.
Courtesy of D. C. Moore Gallery, New York

The Amsterdam fresco is part of an ongoing series I call "Knowledge." All of the works in this series are appropriated from maps that are inaccurate today, but represent the world, as it was then known. Fresco seemed appropriate for these works because it evokes an earlier era, that of the age of discovery, the golden years of cartography.

I really love the beauty, richness, and intricacy of old maps. The more you look at them, the more there is to see. They depicted everything, not just geography—sea monsters, storms, trade, battles, settlements, agriculture, customs, flora and fauna. To me, they are endlessly fascinating records of their cultures. The maps represent societies, biases, and knowledge of their time. I will paint a roomful of these miniatures to reveal the errors that were repeated for centuries and question the validity of any accepted beliefs.

—*J.K.*

LONDON BURNING:

THE CREATION, DESTRUCTION, AND REBUILDING OF A CITY

The treasure that is London is the sparkling jewel in the crown. Many times the character and aspect of the city have changed, "and at this moment the city still lives on and it still changes," and it will forever continue to live and change.[1] The city "has not been made by man, and yet it is the work of man."[2] This work of man has been destroyed and rebuilt, spurred on by natural disasters. London in the sixteenth century was a dense city, with rampant crime, overpopulation, and open sewers breeding disease.[3] This dark, dank, stinking city was getting to be too much for the aristocrats who had started building grand houses along Drury and Chancery Lanes. However, the events of 2 September 1666 transformed the city. The great fire that raged for four days prompted Charles II to issue a proclamation calling for selected commissioners to draw up a plan for the reconstruction of the destroyed area.

Dr. Christopher Wren, a professor of astronomy at Oxford and an architect, quickly came up with a plan for rebuilding the city, and proposed it to the king. Other submissions came from mathematician and scientist Robert Hooke and diarist John Evelyn. Although Wren's utopian plan was not chosen, he continued to devote his life to the beautification and reconstruction of the city of London. The rebuilt St. Paul's Cathedral as well as more than fifty parish churches remain as testimonies to his genius.

One geographical constant of the city is the river Thames. Emile Zola compared it to "an immense mooring street of ships, large and small." The storied river has long provided a focus for architects and engineers to test their skills and build bridges connecting the banks of the city, and to develop the waterfront. But the city of London grew outward from the center toward the west, north, and south, in a sprawling open pattern created by landowners. Nor did the destruction end in the early nineteenth century. John Nash brought an element of order to the city with the creation of Regent Street, a grand artery leading from the royal palace in town to the open country in the

north, which became Regent's Park. There was another fire in 1834 that consumed the Houses of Parliament. The sight was so astounding that the great artist J. M. W. Turner painted the scene on the spot, in the middle of a crowd while watching the fire. With the twentieth century came World War II, when much of the city was heavily bombed. Postwar London's rebuilding is especially evident in the area around St. Paul's and the Barbican.

London's changing face can be seen from maps herewith selected. The expansion of the city from its constricting walls, toward a city with open spaces, came about with the addition of many boroughs. The city is true to being a jewel in the crown, an emerald jewel. It is the parks and gardens that punctuate the heart of the city and are its prized possessions. London is a true metropolis with a dense building fabric in its center, but with an air of humanity that Dickens notes in a "plane tree in Soho" in *A Tale of Two Cities*. However, orientation remains enigmatic, and even a Londoner carries a *London A to Z* guide map. Today, the streets are as chaotic and confusing as they are in the Braun and Hogenberg atlas.

Words written in 1754 may still apply:

> Were the Names of Streets cut on White Stones, the Letters blacken'd, and set up at every Corner, the greatest Stranger might, with the Assistance of a small pocket Map, find his way into any Part of these contiguous Cities and their extended Liberties, without being at the Pain and Trouble of enquiring his Way of a Populace, not the most remarkable for their Politeness to Strangers, or such as do not speak their Language in the native Accent.[4]

Through the beauty of these maps, one hopes that the observer will develop a greater appreciation of London, "whose every street is 'holy, haunted ground,' and whose every byway is fragrant with the spirit of the past."[5]

—*Madhuri Ravi*

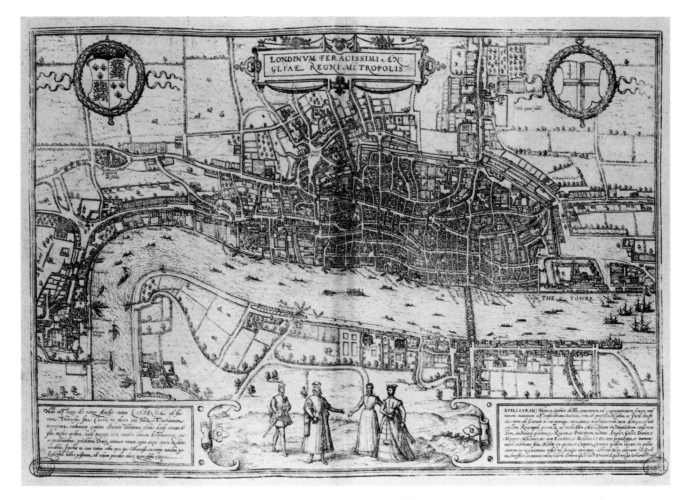

FIGURE 18

Georg Braun and Frans Hogenberg, *London,* from *Civitates
Orbis Terrarum,* 1599, Courtesy of the Trustees of the
Boston Public Library, Rare Book Department

1. Hyatt, 265.

2. Ibid.

3. Shepard et al., 18.

4. John Stranger, *A Proposal or Plan for an Act of Parliament
 for the Better Paving, Cleansing, and Lighting of the streets …
 within the Several Parishes of the City,* London, 1754.

5. Hyatt, v.

Bloom, Harold et al. "Romantic Poetry and Prose," in *The
Oxford Anthology of English Literature.* New York: Oxford
University Press, 1973.

Brown, Lloyd. *The Story of Maps.* New York: Dover Publica-
tions, 1979.

Dickens, Charles. *A Tale of Two Cities.* Philadelphia: Running
Press, 1986.

Elliot, James. *The City in Maps: Urban Mapping to 1900.*
London: The British Library, 1987.

Hyatt, Alfred H. *The Charm of London.* Philadelphia: George
W. Jacobs and Co., n.d.

Hyde, Ralph. *The A to Z of Georgian London.* London: London
Topographical Society, 1982.

Olsen, Donald J. *Town Planning in London: The Eighteenth and
Nineteenth Centuries.* New Haven: Yale University Press, 1964.

Rasmussen, Steen Eiler. *London: The Unique City.*
Cambridge, Mass.: MIT Press, 1967.

Russell, John. *London.* New York: Harry N. Abrams, Inc.,
1994.

Shakespeare, William. *The Complete Works of William
Shakespeare.* New York: Chatham River Press, 1975.

Shepard, John et al. *A Social Atlas of London.* Oxford: Claren-
don Press, 1974.

Summerson, John. *Georgian London.* London: Barrie and
Jenkins, 1962.

———. *Sir Christopher Wren.* Connecticut: Archon, 1965.

Williams, Oscar. *Immortal Poems.* New York: Washington
Square Press, 1960.

1. CITY VIEW IN CIVITATES ORBIS TERRARUM, VOL. I

Georg Braun and Frans Hogenberg
Simon Novellanus, engraver
Cologne, 1599
engraving
32.2 x 51.3 cm
Boston Public Library, Rare Book Department

Why, Sir, you find no man, at all intellectual, who is willing to leave London. No, Sir, when a man is tired of London, he is tired of life, for there is in London all that life can afford.

—Dr. Samuel Johnson in James Boswell,
The Life of Johnson, 1777

Braun and Hogenberg created a map that reflects the development of London in the late sixteenth century. This map shows the entire metropolis of London as it is breaking free of the surrounding walls and expanding to include Westminster and Southwark. London during this period was cramped and overpopulated, and open fields ringed the city limits, which were growing, primarily due to increased trade. In the Braun and Hogenberg map, the river Thames is filled with boats, which signifies the importance of maritime commerce to the city. A dual centered capital was emerging, the city of London as the commercial and manufacturing giant and Westminster as the royal and administrative city. London was swelling both physically and demographically. Population growth was largely the result of immigration.[1]

Braun and Hogenberg had strict regulations for the maps that they selected for the *Civitates Orbis Terrarum.* The maps chosen had to allow the viewer to see into the streets of the city. Another requirement was to depict the daily life of people in different areas—their fashions, social customs, and classes. Here, for example, a group is engaged in playing croquet, a popular English game, indicated by a mallet held by the youngest woman, typical of the artist's introduction of narrative interest in the foreground.

London was the center of royalty for England, the Tower their fortress. Within its surrounding walls is the royal chapel, the last resting place for many of the members of the House of Windsor. There Sir Walter Raleigh was imprisoned, and there the block used for beheading was located. Now, however, many know the Tower as the home of the heavily guarded Crown jewels.

1. Shepard et al., 18.

2. A PLAN FOR REBUILDING THE CITY OF LONDON AFTER THE GREAT FIRE OF 1666

Christopher Wren, designer
Edward Rooker, engraver
The Proprietors at Palladio's Head
in Long Acre, publishers
London, 1749
engraving
29 x 41.2 cm
Harvard Map Collection

O the miserable and calamitous spectacle.... God grant my eyes may never behold the like, who now saw about ten thousand houses all in one flame. The noise, crackling and thunder of the impetuous flames, the shrieking of women and children, the hurry of people and the fall of towers, houses and churches, was like an hideous storm... London was, but is no more.

—John Evelyn, *Diary,* 1666

Christopher Wren was one of eight of London's leading intellectual leaders to submit a plan for rebuilding the city.[1] There were other submissions, such as one by John Evelyn, above, but Wren impressed the king by presenting him with the plan in great haste. He viewed this fire as a chance to improve the city and carry out some new architectural ideas, gleaned from his year in Paris, in 1665.

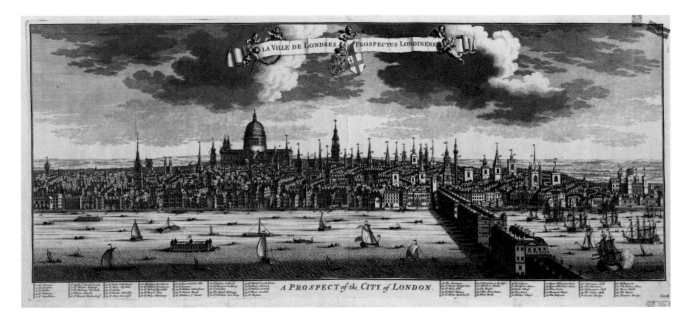

LA VILLE DE LONDRES. PROSPECTUS LONDINENSIS

A PROSPECT of the CITY of LONDON.

FIGURE 19

David Mortier, *A Prospect of the City of London*,
1713, Harvard Map Collection

As apparent from the plan, Wren had strict ideas regarding city planning. He designed radial streets to converge on sites of major buildings or plazas.[2] That point could only be London Bridge, for it was then the most prominent aspect of the city. Further, the astronomers, physicists, and mathematicians of the day believed in pure geometry as the absolute form of beauty.[3] Thus, Wren wanted all the houses to be composed of quadrilateral forms, defined by rectilinear angles at all streets and corners.

Wren's city plan was not chosen but he was put in charge of rebuilding the parish churches in London. From a panoramic view, his work soon dominated the skyline of the city. It was Wren who began shaping the city of London into a "cosmopolitan paradise," for he designed more than fifty churches in his lifetime, and the tall spires still loom large over the old city. The rebuilding of St. Paul's will always remain as a memorial to Wren's architectural genius, as confirmed by the inscription to him (1632–1723): *Si monumentum requiris, circumspice* (If you want to see my monument, look around you).

1. Reps, *The Making of Urban America* (Princeton: Princeton University Press, 1965), 15–19, notes that the most

renowned plans, those of Wren, Evelyn, and Hooke, reflect continental urban schemes then popular.

2. Ibid.

3. Summerson, *Sir Christopher Wren*, 139. See also A. E. J. Morris, *History of Urban Form Before the Industrial Revolutions* (New York: G. Godwin, 1979), 210–34, for maps showing the development of London from the sixteenth to the nineteenth centuries.

3. A PROSPECT OF THE CITY OF LONDON

David Mortier
copy of a plate in *Nouveau Théâtre de la Grande-Bretagne*, vol. 2, nos. 1–2
1713
engraving
56 x 124.2 cm
Harvard Map Collection

A banner held aloft by angelic putti repeats the English title below: *La Ville de Londres*, interrupted by two coats-of-arms, and the rubric *Prospectus Londinensis*, in a magnificently beclouded London sky. From the south bank of the Thames we encounter a bird's-eye prospect of the city after the 1666 fire, newly rebuilt by Christopher Wren. Dominating the densely packed town is St. Paul's Cathedral, whose reconstruction began in 1675 and was nearing completion in 1715. Almost as imposing are most of the fifty rebuilt parish churches, marked by their steepled towers and

weather vanes. Other notable landmarks include The Old Swan and Fishmongers Hall to the left of London Bridge, the latter replete with habitations and commercial establishments, and, to the right, the Custom House and the Tower.

The map presents an extraordinarily clear vista of the urban vernacular, the brick domestic architecture, and the warehouses that replaced the destroyed wooden fabric. We see too a virtual catalogue of maritime traffic along the river—sailing galleys, cargo vessels, barges, gondolas, rowboats, and, to the right of London Bridge, the great ships bound for distant shores.

4. CITY PLAN, from AN EXACT SURVEY OF THE CITY OF LONDON, WESTMINSTER, SOUTHWARK, ETC.

John Rocque, surveyor and publisher
Richard Parr, engraver
London, 1741–45
engraving
67.5 x 48 cm
Harvard Map Collection

…private courts, as gloomy as coffins,
and unsightly lanes
Thrilled by some female
vendor's scream, belike
The very shrillest of all London cries,
May then entangle our impatient steps;
Conducted through those labyrinths,
unawares, To privileged regions inviolate,
Where from their airy lodges studious lawyers
Look out on waters, walks,
and gardens green.

—William Wordsworth, 1850

Labyrinths they certainly were. The streets of London were not kind to strangers. This city plan is the finest eighteenth-century large-scale survey

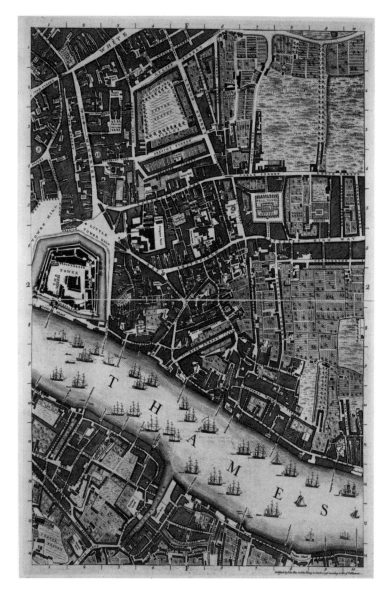

FIGURE 20

John Rocque, *City Plan*, from *An Exact Survey of the City of London, Westminster, Southwark, etc.,* 1741–45, Harvard Map Collection

of London. It offers a clear orientation to the city. Rocque was well aware of the essential components that needed to be included in this map. He knew that the city hall, churches, banks, courts, hospitals, schools, and marketplaces should be flagged. He used symbols for everything, including large private houses with gardens.[1] No attempt is made to show all the individual buildings, only

great houses, public buildings, and palaces.[2] Although this was an excellent guide to the city of London, it was not portable. The atlas format prevented the viewer from seeing the entire city of London at one glance. The main reason for the large format was the scale: twenty-six inches to a mile.

The 1769 editions of the Rocque map show the New Road in 1756, which created a broad thoroughfare in the north of town—a link between the west and the city to the north.

One interesting aspect of the atlas is the list of subscriber's names with which it begins. The list is composed of a variety of people from royalty, government officials, and watchmakers to painters and writers, each having paid three guineas for a copy of the atlas.[3] The government was involved in the Rocque atlas because it was created as the result of an act of Parliament. Along with the map is a key and the original proposal by John Rocque and John Pine, which allows the viewer to see how the twenty-four sheets fit together.[4] The proposal details the exact plan of the map and the areas it will cover, as well as its price and the method of survey.

1. Russell, 151.

2. Hyde, vii.

3. Ibid., iv.

4. Ibid., v.

5. POCKET MAP OF THE CITTIES OF LONDON AND WESTMINSTER

William Roades, engraver
Robt. Hulton, publisher
London, 1743
engraving
29.4 x 45.2 cm
Harvard Map Collection

With this early pocket map, William Roades was marketing to the "traders riding to London with fat purses."[1] Unlike the Rocque atlas, this map was portable, and from its present condition, it looks as if it has been folded, refolded, and stuffed into many pockets during its long life.

London in the eighteenth century was still expanding and trade was continuing to grow. The traveler's map was essential for those who had never been to London, as well as for those who had yet to master the city. These weary travelers wished to "haste to [their] bed, The dear repose for the limbs with travel tired."[2] Without this map, the travelers might not be able to find their beds, for they could very easily become lost wandering the streets of London. Roades created a tool to help visitors navigate the winding streets and thoroughfares of the city.

The map is fairly simple, but it provides a concise view of the city. The most important buildings are delineated. Similar to the contemporary Rocque atlas, there is no attempt to show individual houses and buildings, but the map is on a smaller scale than Rocque's.

Times had changed. Maps created for armchair voyagers, such as those by Braun and Hogenberg, had given way to maps like this one meant to help travelers find their way in the city.

1. William Shakespeare, *The Complete Works of William Shakespeare* (New York: Chatham River Press, 1975), "Henry IV, Part I," Act I, scene 2.

2. Shakespeare, *Sonnet 27: Traveler's Sonnet,* 1195.

6. MAP OF LONDON DEDICATED TO WILLIAM THE FOURTH MADE FROM AN ACTUAL SURVEY IN THE YEARS 1824–26

Christopher Greenwood, cartographer
Josiah Neele, engraver
London, 1830
hand-colored engraving on six sheets
72 x 65.5 cm each
Harvard Map Collection

I wander thro' each charter'd street,
Near where the charter'd Thames does flow.
And mark in every face I meet
Marks of weakness, marks of woe.

—William Blake, *London,* 1793

Christopher Greenwood's map and William Blake's lines of poetry certainly provide singular views of London. Greenwood shows the beauty of the physical city in its overall layout. He also gives us insight into the character of the city and how it grew into its present state. We admire the map, its colors and immense size, and wonder where to begin looking. Blake's words, on the other hand, have scratched the surface and suggest the sights and sounds of the city, not simply majestic and colorful anymore, but rather, filled with voices, screams, laughter, and the human heart.

The Greenwood map is printed in six sections and is based on a survey done in the years 1824–26. Both lower corners of the map are illustrated with important monuments of London, specifically Westminster and St. Paul's. A scale and a key allow the viewer to read the map easily. Greenwood used bright, bold colors to attract the viewer, but the overwhelming sensory responses confuse the view. Herewith, are some tips to read the map in an orderly fashion: First, locate the Thames as it winds its way through the city. Most major monuments

are situated along its banks, the majority on the north side. Reading from east to west, note the Tower of London, St. Paul's, the Houses of Parliament, and Big Ben. Next, find the large green areas of Regent's Park and Kensington Gardens, which form welcome breaks in the urban fabric, revealing the many open spaces in the city—as important as major thoroughfares. Dickens makes their sigificance apparent in *A Tale of Two Cities* (1859), wherein he writes: "there were few buildings then, north of Oxford Road, and forest-trees flourished, and wildflowers grew, and the hawthorn blossomed, in the now vanished fields."[1]

1. Charles Dickens, *A Tale of Two Cities* (Philadelphia: Running Press, 1986), 70. For the extensive open areas in present-day London, see Shepard et al., 35.

7. THE TATE GALLERY BY TUBE MAP OF THE LONDON UNDERGROUND

One of a series of new paintings commissioned by the London Underground Limited
David Booth
1987
offset lithograph
35.5 x 81.3 cm
London Transport Museum

The Underground…In all guides, in all
stations its map confronts you, as lucid,
stable and pretty in its primary colors as
a Mondrian…Be warned; this map…is a
triumph of omission, and a highly platonic
vision of the abstract ideal underground.

—David Piper, *The Companion Guide*
to London, 1964

The movement of London is continuous, and the Tube reflects the idea of speed and efficiency that is so important to its inhabitants. Begun in 1854, it was the first underground people-mover in the world. It is due to the London Transport System that the city has grown significantly. In plan, this system is the only regular aspect of London.

The Underground reflects the growth of the city of London. This system of transport is as much a part of the city as Buckingham Palace, Covent Garden, or Trafalgar Square. In fact, the London Underground fostered the expansion of the city, and continues to do so today as the Jubilee Line Extension is creating new developments in south and east London.

The London Tube map was created to encourage the additions of murals and other artwork to the subway stations, in order to make them more aesthetically pleasing. It is a map that is both stylized and generalized, but easy to comprehend. The upper part of the map showing the different lines of the subway system gives one an idea of the location of the city center. There is a multitude of crossing lines near Piccadilly Circus and Tottenham Court Road, reflecting their positions at the heart of the city. The bright colors used are purposeful, for they reflect the color palette of the underground system. Perhaps a pun is intended in the tube of paint, with the logo of the station "Pimlico" (for the Tate), the only graphic on the poster.

Wordsworth wrote of "…the quick dance of colours, lights and forms, the deafening din,"[1] and it is as if the poet were watching the Piccadilly train going by, with its bright flash of colors. Below is order, above is chaos. The underground is a color-coded, comprehensible world.

1. William Wordsworth, "Residence in London, Romantic Poetry and Prose," vol. 7, *Oxford Anthology of English Literature* (New York: Oxford University Press, 1973), 212.

MANNAHATTA . . . A ROCKY FOUNDED ISLAND

The cartographic history of Manhattan is revealed in its evolution from a once sparse, rocky island through various stages of development to the present-day metropolis. The surviving maps, dating back to the early sixteenth century, help paint a detailed picture of Manhattan island as it changed from its period of discovery to its state today as the center of a vast urban agglomeration.

The earliest maps of Manhattan, dating from the Maggiolo map of 1527 (now lost) up to the turn of the nineteenth century, are the most artistically rich portraits of the city. Color and elaborate ornamentation are major factors in these maps, and most are finished with watercolor and, sometimes, gilded details, as in the famous *Duke's Plan* of 1664. Cartouches often adorn the corners of the maps, together with decorative borders, fanciful inscriptions, and sometimes small figures. Early maps of New York (originally New Amsterdam) reflect the great age of Dutch cartography. And, because of New York's strategic importance in the years preceding the War of Independence, the city was extensively mapped for military reconnaissance by British engineering surveys.

With the approach of the nineteenth century and the sudden growth and expansion of New York City, the cartographic representations became increasingly factual and relatively accurate, while the artistic qualities slowly disappeared. This transformation is best marked by the Commissioners' Plan of 1811 that set forth the notorious, if practical, grid-iron plan of the city. From this point forward, not only were virtually all maps of the city divided into checkerboard patterns, but the focus was predominantly on real estate, urban planning, and building, as well as issues of space management. Accuracy and precise, recognizable details took the place of inventive craftsmanship.

In 1857, a fortunate exception broke the rigid grid of the Commissioners' Plan, when Frederick Law Olmsted and Calvert Vaux won the competition to build Central Park. The first urban park in America, it represented a "natural" oasis of greenery and water amidst an otherwise densely built city.[1] Reaching two and a half miles north from Fifty-ninth Street to 110th Street, and east-west from Fifth Avenue to Eighth Avenue, the park embodied nineteenth-century romantic and pastoral concepts of landscape architecture. Originally designed as a civilizing element of urban life in the increasingly industrial society, its economic potential was soon made manifest in the rising property values of the surrounding areas.[2]

The development of Central Park was one of the most extensive public works projects in Manhattan during the nineteenth century. Its 843 acres consisted of uneven, extremely rocky terrain, complete with swamps and bluffs. To conform to the natural landscape, Olmsted and Vaux's plan, called the "Greensward" was conceived with three primary components, namely, "the pastoral," or the open, rolling meadows of the park; "the picturesque," as seen in the rambling, winding paths; and "the formal" aspects of the promenade and mall areas.[3]

Examining the pictorial evolution of maps of Manhattan, we learn much about the changing needs and mores of its citizens. Just as the earlier generations satisfied their desire to share in the exciting discovery of a new island by producing lovely images of it, albeit often for strategic reasons, so did the inhabitants of the nineteenth and twentieth centuries recognize the necessity for practicality in planning, as seen in the more purposeful maps.

—*Milica Curcic*

1. Eric Homberger, *The Historical Atlas of New York* (New York: H. Holt and Co., 1994), 88.

2. Ibid.

3. Jackson, ed., 198.

Augustyn, Robert T., and Paul E. Cohen. *Manhattan in Maps 1527–1995*. New York: Rizzoli International Publications, Inc., 1997.

Jackson, Kenneth T., ed. *The Encyclopedia of New York City*. New Haven: Yale University Press, 1995.

Stevenson, Edward L. *Portolan Charts: Their Origin and Characteristics.* New York: The Knickerbocker Press, 1911.

Wolff, Hans. *America: Early Maps of the New World.* Munich: Prestel Verlag, 1992.

———

1. Map of the Original Grants of Village Lots from the Dutch West India Company to the Inhabitants of New Amsterdam (now New York) lying below the present line of Wall Street

Dunreath Tyler, publisher
New York, twentieth-century facsimile
of 1642 original
colored engraving
48 x 61 cm
Harvard Map Collection

Focusing on "grants commencing 1642," this map reconstructs the southern tip of the island viewed from the East River and extending to Wall Street. Oriented toward the northwest, the North (Hudson) River is at the top. Plots are indicated in bright colors upon which are inscribed names of original owners and dates, as also size, given in rods and feet. Principal arteries are marked with earlier and later names: for example, the Great Highway, now Broadway; the Common Ditch and Sheep's pasture, now Broad Street; the Marketfield Road, now Whitehall Street. Along the Strand (now Pearl Street) fronting the East River, the plots are long and narrow, reminiscent of Dutch houses. Names familiar in early New York history are property owners, none more prominent than that of Peter Stuyvesant, whose plot is adjacent to the West India Company's garden. Peter Stuyvesant, governor general of the colony, 1647–64, surrendered the fort and city to the British in 1664.

Fort Amsterdam, at the foot of Broadway, is marked as the site of the new Custom House. Does this rubric designate the grand Beaux-Arts U.S. Custom House designed by Cass Gilbert in 1907? Or does the date 1809 (?) on the map refer to the lodging that was used as a Custom House until it was torn down in 1815?[1]

1. See John A. Kouwenhoven, *The Columbia Historical Portrait of New York* (New York: Harper and Row, 1972), 88.

———

2. The Duke's Plan (A Description of the Towne of Mannados or New Amsterdam)

Jacques Cortelyou, cartographer
drawn 1664; depicted 1661
facsimile by George Howard for
D. T. Valentine's Manual, 1859
lithograph original watercolor and gold on vellum
59.5 x 77.2 cm
Harvard Map Collection

SEA-BEAUTY! strech'd and basking
One side thy inland ocean laving, broad,
with copious commerce, steamers, sails,
And one the Atlantic's wind caressing,
fierce or gentle—mighty hulls dark gliding
in the distance.
Isle of sweet brooks of
drinking-water—
healthy air and soil!
Isle of the salty shore and breeze and brine!

—Walt Whitman, *Leaves of Grass,* 1855

In the year 1664, what had been a Dutch colony established by the Dutch West India Company in 1624, was abruptly seized by the British under the command of Colonel Richard Nicolls. Possession of the island of Manhattan shifted into the hands of James, Duke of York, who initiated a new developmental process. The careful organization of streets, plots of land, and gardens was extended northward, beyond the protective ditch and wall (present-day Wall Street) under the progressive British governance. Along with the development came a re-naming of the major sites and geographical features on the island. The North River became the Hudson; Fort Amsterdam, visible at the tip of the island, was renamed Fort James (today, Battery Park) after the duke; and Manhattan became New York City, in homage to its new owner.[1]

This famous map (whose original is in the British Library), referred to as the *Duke's Plan,* was painted from a survey by Jacques Cortelyou as a document of ownership for the Duke of York at the time of the triumphant siege of the island. Accordingly, the English flags are depicted at the fort on the tip of the island, as well as on some of the small ships. Particularly beautiful in its detail, the map was essentially a "trophy" piece to be presented to the duke, a flattering depiction of his new possession.[2] Considered one of the most beautiful representations of Manhattan island, its colors and exquisite details have rarely been surpassed in maps of New York.

Particular attention has been given to the cartouche painted on the left side of the map, that describes it as "A Description of the Towne of Mannados or New Amsterdam as it was in 1661," as well as to the intricate and ornate border, both of which are related to Dutch cartography of this period. Rivers around the island provide the space for ornamental embellishment and clipper ships, thereby perpetuating the pictorial tradition of earlier maps, still prevalent in the seventeenth century.

1. Augustyn and Cohen, 42.
2. Ibid., 43.

3. A Plan of the City and Environs of New York as they were in the Years 1742, 1743 & 1744

David Grim, cartographer
G. Hayward, lithographer
1813 facsimile published by
D. T. Valentine's Manual, 1854
61 x 48.5 cm
Harvard Map Collection

This depiction of New York City as it appeared in the early 1740s was drawn by David Grim in 1813. The accuracy of the exquisite detail here enhances the important function of this map as a historical document.

Several recognizable elements can be identified: the fort at the tip of the island; the stream that flows out of Collect Pond that parallels present-day Canal Street; the wide street that cuts vertically through the entire tip of the island, the present-day Broadway; and the palisade from the Hudson to the East River, as a defense against attack by the French. New to this map, and to the island, is the extensive development and cultivation of land that appears to have taken place north of this "Wall." Careful planning has been carried out, involving the division of this once swampy land into farms and gardens. Such areas would eventually become estate property of the wealthy citizens of the city.[1]

At the bottom of the map is an itemized key to the locations of various commercial spots; among these, tanneries and breweries dominate the major industries. On the other hand, the top panel depicts an encyclopedic succession of significant landmarks from this period, including Fort George, the Poor House, City Hall, Trinity Church, and various religious buildings (e.g., Lutheran Church, Quaker Meeting House, synagogue). From these, one can discern much about the culture, specifically about the diversity of religious interests.

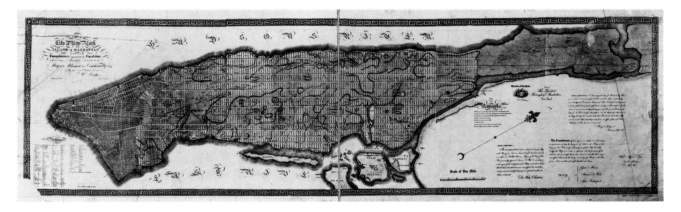

FIGURE 21

John Randel, Jr., *The Commissioners' Plan,* mid-ninteenth-century
facsimile of 1811 original, Map Division, The Research Libraries,
The New York Public Library, Astor, Lenox, and Tilden Foundations

Perhaps the most crucial detail, however, is
the blatant evidence of slavery as it existed and
became increasingly prevalent at this time. Among
the numbered items in the key are the locations of
gallows, mostly north of the Wall, where lynchings
and executions took place. An inscription on the
back of the original map denotes the horrific
details of such events, and also documents the first
slave uprising in New York in 1741.[2]

1. Augustyn and Cohen, 62.
2. Ibid.

4. PLAN OF THE CITY OF NEW YORK

Bernard Ratzer, cartographer
T. Kitchin, engraver
Faden and Jefferys, publishers
London, surveyed 1766–67; published 1770
copperplate engraving
61 x 91.3 cm
Harvard Map Collection

Bernard Ratzer's improvements of John Montresor's
military survey of 1766 resulted in "perhaps the
finest map of an American city and its environs
produced in the eighteenth century."[1] As a military
engineer, Ratzer was recruited by the British and
sent to survey the city of New York in the years
prior to the American War of Independence.

Oriented toward the northwest, the vista is
from Long—or Nassau—Island (which includes
the Brookland Ferry) extending to today's Green-
wich Village along the Hudson. Among the details
on the map, there are clearly written street names,
squares, and wards. We note that Bowery Lane
becomes the Road to Boston, and the bend in the
East River, known as Crown Point, indicates salt
marshes to the north. The "Fresh Water" lake is
part of a reservoir, located along present-day
Canal Street.

A magnificently ornamented cartouche frames a dedication to Sir Henry Moore, captain general and governor of New York and its territories. References to important landmarks include forts, churches, meeting houses, public buildings (City Hall, prison, poor house, exchanges, barracks) and markets, slips, docks, and warehouses.

In 1767, Ratzer made an additional survey of Manhattan and environs. In his maps, we are dazzled by the topographical variations and the quasi-agrarian landscape north of the developed area. City and country are closely tied, the island being an "attractive combination of cultivated fields, forests, and salt meadows, interspersed with large estates possessing fine, geometric gardens."2

The Ratzer plan is an excellent example of the links between cartography and military reconnaissance. Hence, it is not surprising that it was revised in 1776.3

1. Augustyn and Cohen, 73. See 70–77, for the Montresor and two Ratzer maps.
2. Ibid.
3. James Elliot, *The City in Maps: Urban Mapping to 1900* (London: The British Library, 1987), 62.

5. THE COMMISSIONERS' PLAN

A MAP OF THE CITY OF NEW YORK BY THE COMMISSIONERS APPOINTED BY AN ACT OF THE LEGISLATURE PASSED APRIL 3RD 1807

John Randel, Jr., cartographer
Robert A. Welcke, printer and publisher
New York, mid-nineteenth-century facsimile of 1811 original
photolithograph
96.4 x 29.3 cm
Map Division, The Research Libraries
The New York Public Library, Astor, Lenox, and Tilden Foundations

To [the commissioners] the great city of the future was to be simply an enlargement of the primitive town of their own day…their one desire seems to have been to make use of every available square foot of land for strictly utilitarian purposes…Of artistic thought there was not a suggestion…[Their plan had] lain like a huge gridiron on the city, binding it to hopeless monotony and humdrum commercialism of aspect, and acting as a barrier to any attempt to impart to the town that grand metropolitan air which distinguishes most of the great capitals of Europe.

—Ernest Flagg, *Scribner's,* 1904

The sparsely inhabited island of Manhattan was once no more than a strategic trading peninsula. Developed swiftly under the Dutch and subsequent British rule, the city suffered before and during the Revolution. As the temporary capital in 1789, New York soon became the nation's leading commercial and economic center.

What predisposed the city to an even more secure path for future growth was the famous Commissioners' Plan of 1811, a plan approved by the New York State legislature, creating twelve broad north-south avenues and 155 east-west streets. It divided the land of the entire island into a rectilinear grid; the one exception to the plan was Broadway, the street that cuts through the grid on a diagonal.1

Oblivious to the island's rocky topography and its natural pastoral landscape, the plan did not allow for sufficient open space; it did, however, create unparalleled opportunities for speculators. The proposed benefits of the plan were primarily economic, for the designers believed that straight streets would encourage development and ensure the best possible use of all plots of land. An additional concern was

public health. It was thought that the proposed layout of the streets would provide "free and abundant circulation of air" throughout the city. Consider the commissioners' remark "…that a city is to be composed principally of the habitations of men, and the strait sided and right angled houses are the most cheap to build, and the most convenient to live in."[2]

Later developments and alterations to the plan included the addition of Times Square and Central Park in the late 1850s. For the most part, however, the Commissioners' Plan has prevailed. New York City has grown into the most densely populated city in our country, but, ironically, the notorious grid has made it the most manageable.

The Commissioners' Plan of 1811 not only altered the expansion of Manhattan, but also profoundly affected the evolution of its cartographic representations. As Lewis Mumford claimed, "With a T-square and a triangle, finally, the municipal engineer, without the slightest training as either an architect or a sociologist, could 'plan' a metropolis."[3]

1. Kenneth T. Jackson, *The Encyclopedia of New York,* 1995, 718.

2. Reps, *Urban America,* 296–99.

3. Cited in Augustyn and Cohen, 102. See also 100–08.

6. NEW YORK AND ENVIRONS

John Bachmann
1859
color lithograph
59.7 cm diameter
Eno Collection, Miriam and Ira D. Wallach
Division of Art, Prints, and Photographs
New York Public Library, Astor, Lenox,
and Tilden Foundations

This unusual fish-eye view of Manhattan island prominently displays the densely developed city in the foreground and stretching into the distance, while also emphasizing the way in which urban civilization has now extended into Jersey City, Hoboken, Brooklyn, and Williamsburg, as seen on the edges of the orb. Although the map is somewhat distorted due to its spherical shape, one can clearly sense the immense urban growth that has occurred in the northern sector of New York City. This period of development is commonly referred to as "moving uptown," and was partially the result of the tragic fire of 1835 that demolished much of the inhabited districts on the southernmost tip of the island.[1]

The map that was drawn "from nature on stone" by John Bachmann, and subsequently published in 1859, intentionally utilizes the perspective of New York-as-top-of-the-world to lend a feeling of optimism to the work and "suggests…[a somewhat] exaggerated conception of the city's global consequence on the eve of the Civil War."[2] The major accomplishments and monuments of the mid-nineteenth century in the city are clearly discernable. Most obvious are the parks, specifically Battery Park and the Bowling Green, that seem to protrude into space, placed as they are at the tip of the island and the center of the orb, and far to the north, the newly created Central Park. Also notable is the number of carefully rendered church steeples, punctuating the uniform urban fabric. Most of these are now located in the northern sections of the island, a trend that coincided with the growth of many new communities in those areas. There were 290 churches in Manhattan by 1857, 206 more than in 1825, only thirty-two years earlier.[3]

Clearly this was a time of prosperity and unprecedented expansion for New York City. The bird's-eye view encapsulated within an orb is the ideal way to present the accomplishments and status of the city.

1. Homberger, 90. See also Augustyn and Cohen, 117.

2. Kouwenhoven, 287.

3. *Moving Uptown: Nineteenth-Century Views of Manhattan.* Exhibition label text, New York Public Library, 1998.

7. New York from the Steeple of St. Paul's Church, looking East, South, and West

Henry Papprill, after John Wm. Hill
New York, 1849
etching and aquatint
54 x 92.3 cm
Fogg Art Museum, Harvard University
Art Museums, Walter A. Compton Bequest Fund

From St. Paul's steeple, affixed to the 1766 chapel in 1794—the church being the only extant pre-Revolutionary building in eighteenth-century New York—a bird's-eye view reveals the density of lower Manhattan. From the crossroads of Fulton Street and Broadway, our vista extends down the main thoroughfare to Trinity Church and beyond to the Hudson River and the New Jersey shore. A vibrant panorama unfolds to represent a crowded hub of varied commercial activity, and also domestic habitations marked by laundry hanging on rooftops, all woven together in a dense urban fabric. The average building is on a narrow plot, four or five stories in height, some with pitched roofs, others flat, and most with wide expanses of casement windows. A few church towers dot the townscape, while the shore is alive with all types of sailing ships.

Most fascinating is the variety of urban activity, ranging from Barnum's Museum to clothing, jewelry, furniture, glass, painting, and manufacturing establishments. Perhaps most intriguing is Brady's Daguerrean Miniature Gallery just opposite the churchyard of St. Paul's. Recall that the daguerrotype had been invented only ten years earlier, and that Mathew Brady's famous Civil War photographs lay in the future. Street traffic is lively, and includes an ice delivery, but it is dominated by horse-drawn carriages and pedestrians.

8. Miller's New Guide to Central Park

T. Addison Richards, illustrator
L. Prang & Co., Boston and New York
James Miller, publisher
New York, 1870
lithograph
22 x 89 cm
Frances Loeb Library, Graduate School
of Design, Harvard University

The map is part of a small-format, 101-page guide that begins with the origin and history of the park; continues with chapters discussing the area, cost, and various parts of the park, the structures, the zoo, the birds, the flowers, the cascades, and the arboreteum; and concludes with the designers, government ordinances, and the future of the park. Charming illustrations enhance the guide, such as the color lithograph frontispiece titled "Fancy Bridge no. 14," and a number of sites and monuments, including a bust of Schiller and an iron footbridge.

The long, narrow map appears to be drawn to the same ratio as is Central Park to Manhattan. Here we see the picturesque, bucolic, rambling elements of the park—its ponds, lakes, waterfalls, arbors, and meadows—often deemed the greatest work of architecture in New York. A great variety of structures and experiences complements that of nature: old forts, stone and iron bridges, the music pavilion, menagerie, refreshment saloon, summer house, and the clearly marked promenade leading to the mall with its climax at the Bethesda Fountain. Here the circulatory system reveals footpaths, pedestrian walks, bridal paths, carriage drives, bridges, overpasses, and underpasses. Most extraordinary are the crosstown transverse roads, remarkably prescient in their time, and used for today's motor traffic.

By far the most prominent feature is the Croton Reservoir, the original parallelogram and the present amoeba-shaped lake, designed by engineer Egbert Viele. Buildings are few at this time—the Old Arsenal in the south, Mt. St. Vincent in the north. The great encroachment of institutions and recreation facilities, ranging from the Metropolitan Museum of Art to the Wollman Skating rink, are largely twentieth-century interventions. All the streets from Fifty-ninth to 110th and the avenues from Fifth to Central Park West are schematically marked, as are a few restaurants, including a Ladies and Gents Dining Saloon and a hotel.

"Greensward," by Frederick Law Olmsted and Calvert Vaux, won the competition for the park's design, begun in 1858. The architects had a democratic vision of a place in which all social classes would gather for peace and tranquility, finding there a respite from the turmoil of the city and a stimulus to the imagination. In the words of Olmsted (cited in the guide), the park was meant "to produce a certain influence in the minds of the people, and through this to make life in the city healthier and happier."

9. BROADWAY BOOGIE WOOGIE 1996 #7

Spelman Evans Downer
1996
oil and drawing on panel
16 x 16 in.
Collection of the artist

Broadway Boogie Woogie 1996 #7 is part of my long-running series of aerial paintings of New York City. This painting was inspired by Piet Mondrian's *Broadway Boogie Woogie,* one of his last and most famous paintings that interweaves the complex, inprovisational rhythms of the city's nightlife with the rectilinear compositions so reminiscent of the urban design of Manhattan.

This *Broadway Boogie Woogie* graphs the actual street design of New York City, which includes in this location both West Broadway and Broadway. The three twisted panels suggest the energy and syncopated jazzy, edgy feel of New York, thereby referencing both the experiential quality of the city as well as its urban design.

—*S.E.D.*

10. THE WONDERFULNESS OF DOWNTOWN

Jane Hammond
1999
silkscreen and lithograph with collage, ed. 49/50
65 x 68 in.
ULAE Publishers, New York

Most maps were made for sailors and explorers. People don't need a map of home; they need a map of the unfamiliar. All cartographers and all map users, with rare exceptions, were men. Usually, it was about conquest or, at best, trade. The features the old maps describe are permanent, or perceived as permanent, and the attempt is to be as precise as possible. So I thought it would be interesting to turn all that around.

My map is made by a woman and shows a woman explorer. It depicts the familiar (my home, lower Manhattan) and it depicts it "by feel"; streets are not named, and the drawing isn't precise. The photographs, taken roughly where they are located on the map, depict incidental, particular, everyday things: a reliquary for a dead bird at Tompkins Square Park; three Dominican men outside a funeral home; a colorful, hand-painted dragon boat that was moored in the Hudson for awhile; a cat sitting on my front steps. The things the world is really made up of.

—*J.H.*

BOSTON:
GROWING BY LAND AND BY SEA

Massachusetts has been the wheel within New England,
and Boston the wheel within Massachusetts. Boston therefore
is often called the "hub of the world," since it has been the source
and fountain of the ideas that have been reared and made in America.

—The Rev. F. B. Zinckle, *Last Winter in the United States,* 1868

Boston is located on the Shawmut peninsula. In 1620, the peninsula was first inhabited by the Reverend William Blaxton, who sought peace and quiet in order to garden and read his many books. His solitude was broken when, in 1630, Governor John Winthrop moved the colony of settlers from Charlestown to Boston in search of a good water supply.[1] The colonists named the new settlement Boston "for the town of the same name far behind in East Anglia."[2] Boston's early topography was marked by three hills—Mount Pemberton, Mount Vernon, and Beacon Hill, forming the "Trimountain." This topography was gradually amended by the settlers to accommodate a growing population and ease access to the sea. From 1811, the hills were torn down and the earth removed to be used as landfill for the Mill Pond (once the north cove, a dam that was supervised by mill proprietors). The peninsula's contour also changed as it was continually being filled with piers that extended farther into the harbor. Faneuil Hall was built on the site of the town dock as a marketplace. Boston soon grew into the nation's most important maritime city.

John Bonner's map of 1722, the first published map of the city, reveals the prominent features of early colonial Boston and its network of streets. The labyrinthine pattern of streets seemed to follow earlier cow paths, which are still likened to the current roads that continue to plague drivers today. Boston's growth from a colonial settlement to a leading port can be traced through the maps presented herewith.

As Boston became the busiest port in America in response to its booming trade in all manner of goods, a grid pattern for the streets was proposed "on the northern slope of Beacon Hill... [and] indicates a fairly early attempt to break away from the rambling alignment of the city's streets elsewhere."[3] Along with the increasing number of thoroughfares, the harbor continued to grow largely by means of land redemption. The view of Long Wharf, 1768, reveals the continued significance of the harbor to the city. Finally, Boston's expansion led to the obliteration of Boston Neck, beginning in the early nineteenth century with the process known as "landfilling." The three hills, noted above, were "scraped down" and used to fill in the marshland and bay. In the 1850s, landfilling served to further expand the city of Boston, creating such areas as the Back Bay. A grid pattern was implemented for the newly formed Back Bay, clearly visible in maps after that date. The pattern recalls the grid imposed by the 1811 Commissioners' Plan for Manhattan, in marked contrast to the cow paths of the pre-Revolutionary city.

With the growth by land and sea came a surge in the population that reached 12,000 by 1722. The density of population in the city led to a decrease in recreational space, as most of the land was utilized for commercial purposes. In 1839, the Public Garden was established on the once-water-covered land as a place of greenery to be enjoyed by Boston's citizens. The elegant and highly structured form of the Public Garden is beautifully captured in Edwin Whitefield's watercolor, painted in the 1860s, in the collection of the Boston Athenaeum. It stands in stark contrast to the informality of the Boston Common as seen in the 1934 souvenir map in the Boston Athenaeum. Frederick Law Olmsted's park system,

known as the Emerald Necklace, begins at the Boston Common, continues with the Public Garden, founded in 1839, extends to Commonwealth Avenue, through the Fenway, and ends in Franklin Park.

One would think that, with the expansion by sea through additional harbor wharves and expansion by land through the scraping down of hills and landfilling, there would be nowhere else to go. Today the focus is South Boston and its potential for growth as witnessed by "the new Court House on Fan Pier, a new hotel, and constant talk of a new convention center in the offing."[4] Above all, the mind-set of tearing down and building up continues in the mammoth engineering project now underway—the depression of the Central Artery and the creation of the new harbor tunnel.

—*Chris Chanyasulkit*

1. Reps, 140.

2. Ibid.

3. Ibid., 141.

4. Haley and Steele Gallery, *Cutting Down, Filling In, Spreading Out,* Boston, 1997.

Beveridge, Charles E., and Paul Rocheleau. *Frederick Law Olmsted: Designing the American Landscape.* New York: Rizzoli International Publications, Inc., 1995.

Branch, Melville C. *An Atlas of Rare City Maps: Comparative Urban Design, 1830–1842.* New York: Princeton Architectural Press, 1978.

Fabos, Julius, Gordon Milde, and V. Michael Weinmayr. *Frederick Law Olmsted, Sr.: Founder of Landscape Architecture in America.* Boston: University of Massachusetts Press, 1968.

Harper, Dorothy. *Eye in the Sky: Introduction to Remote Sensing.* Montreal: Multisciences Publication Limited, 1976.

Jolly, David C. *Maps of America in Periodicals Before 1800.* Brookline: Brookline Publishers, 1989.

Krieger, Alex, and David Cobb, with Amy Turner, eds. *Mapping Boston.* Cambridge, Mass.: MIT Press, 1999.

Reps, John William. *The Making of Urban America; A History of City Planning in the United States.* Princeton: Princeton University Press, 1965.

Shand-Tucci, Douglass. *Built in Boston: City and Suburb 1800–1950.* Amherst: University of Massachusetts Press, 1988.

Southworth, Michael, and Susan Southworth. *AIA Guide to Boston.* Old Saybrook: Globe Pequot Press, 1992.

Whitehill, Walter Muir. *Boston: A Topographical History.* Cambridge, Mass.: The Belknap Press of Harvard University Press, 1968.

Zaitzevsky, Cynthia. *Frederick Law Olmsted and the Boston Park System.* Cambridge, Mass.: The Belknap Press of Harvard University Press, 1982.

1. THE TOWN OF BOSTON IN NEW ENGLAND

John Bonner
Boston, 1722
engraving
60 x 74 cm
Boston Public Library, Rare Book Department

A fine harbor in Boston and a proper water supply led to the transfer of the seat of government from Charlestown, where Governor John Winthrop had established the Massachusetts Bay Colony in 1630.[1] The earliest town plan of Boston, the John Bonner map of 1722, reveals the progress that the city had witnessed in its first nearly one hundred years. We see the peninsula's original topography, the street layout, houses, schools, churches, and wharves. We note fortifications on the Common—Fox Hill, Powder House, and Watch House—as well as a garden and burying ground, rope walks, and, to the southeast, Fort Hill (now International Place). We recognize street names—King Street (now State) leading to Long Wharf and Orange (now Washington) and connecting the peninsula to the mainland. A street system, buildings, and gardens appear on the land once thought of as made by "a calf walked home as good calves should; but made a trail all bent askew, a crooked trail as all calves do."[2] The importance of the water is revealed by the extension of the Long Wharf from its original length when begun in 1710.[3] The two sides of the harbor are also connected by the "Old Wharfe," an appropriate name as the wharf, built in 1673, "fell into disuse, and outbound vessels used the stone from which it was constructed as ballast."[4] The inset in the lower part of the map gives the scale, information on principal buildings and their dates, and lists the great fires and smallpox epidemics in Boston. Buildings cited include the Old Church, the Old North, the Old South, and the Church of England (now King's Chapel), the Town House, and the South Grammar School.

At the time the map was made, the city's population had reached 12,000, making Boston the most populous city in the English colonies and leading to the expansion of the peninsula, docks, and wharves.[5] The growth may be seen in the 1769 John Bonner map, for which this map served as the template. Demographic statistics indicate Boston was the third largest city in British North America, but that the population had been stable since the first Bonner map. Whitehill notes that "because of this it still stayed within the bounds of the Shawmut peninsula with a comfortable air of space, not only on the Common and the Tri-mountain, but even in the streets of the South End. It still, after a century and a third, remained isolated from the mainland."[6]

1. Reps, 141.
2. Sam Walter Foss, "The Calf Path," in *Whiffs from Wild Meadows* (Boston: Lee and Shepard, 1896), 77.
3. Reps, 141.
4. Ibid.
5. Ibid.
6. Whitehill, 44.

2. VIEW OF BOSTON

The American Magazine, 1743
James Turner, engraver and publisher
woodcut
7 x 11 cm
Boston Athenaeum

This miniature woodcut on the title page of *The American Magazine* depicts a panorama of the city, focusing on the harbor, the maritime activity, and the church steeples, which dominate the landscape. Two vignettes below present forested scenes populated by native Indians. Turner's print, probably derived from William Burgis's view, was published in the same year, 1743.[1]

1. Gloria G. Deák, *Picturing America, 1497–1899,* 2 vols. (Princeton: Princeton University Press, 1988), vol. I, no. 94, 58; vol. II, fig. 94 .

FIGURE 22

James Turner, *View of Boston* from *The American Magazine,*
1743, Boston Athenaeum

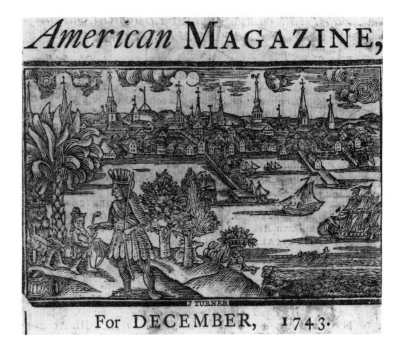

3. PLAN DE LA VILLE ET DU PORT DE BOSTON, CAPITALE DE LA NOUVELLE ANGLETERRE

Jacques Nicolas Bellin
Paris, 1764
hand-colored engraving
68.5 x 81.8 cm
Courtesy of the Norman B. Leventhal
Map Collection

By the middle of the eighteenth century, Boston had lost its position as the largest colonial town, moving to third place behind Philadelphia and New York. This lack of growth allowed the city to remain within the topographic boundaries of the Shawmut Peninsula, rather than expand to the surrounding marshlands. Produced by the hydrographer to the king and published under the auspices of the French marine office, this rare plan may be compared to the best of the French manuscript maps, but was probably based upon an English survey copied by Bellin for use during the French and Indian War.

Beautifully engraved, Bellin's map is the earliest detailed plan of Boston published in France.[1] It includes streets, houses, public buildings, wharves, and such specific locations as Beacon Hill and the Common, as well as routes to surrounding districts—Cambridge, Roxbury, and Dorchester. Emphasis on fortifications is apparent in the harbor, with the *Château Castle dans l'Isle* clearly drawn, and in the Common, with its powder magazine and liberty tree.

Scale is indicated in French and English measures, and the maritime nature of the map is reinforced by the citation of latitude (42° 24') and longitude (53° 26' west of London and 53° 14' from Paris). A legend at the upper left notes the city's founding in 1630 and its division into twelve districts in 1738, each with an infantry company. Ten fires are listed from 1653 to 1760. At the lower left, important buildings are named, such as the State House, Customs Office, Alms House, and Prison. A description at the upper right notes the importance of the city, praises its beauty, its military installations and churches of different denominations, and notes the market day and fairs.

1. I would like to thank David Cobb, Harvard Map Collection, for providing the information on the two maps from the Norman B. Leventhal Map Collection in this exhibition.

4. A VIEW OF THE TOWN OF BOSTON IN NEW ENGLAND AND BRITISH SHIPS OF WAR LANDING THEIR TROOPS, 1763

Paul Revere, publisher and seller
after Christian Remick
Boston, 1768
hand-colored engraving
26.5 x 40.6 cm
Boston Athenaeum

The Long Wharf as depicted in this engraving by Paul Revere remotely recalls the pictorial qualities of the bird's-eye views in the Georg Braun and Frans Hogenberg maps. This panoramic view, drawn in 1768 and published in 1770, takes the armchair traveler through Boston, as seen from the water looking toward the Long Wharf. Spires of

churches punctuate the densely packed waterfront, attesting to the presence of religion in the maritime city. The Old North Church dominates the skyline; here the map's author hung his lanterns in the steeple on 18 April 1775 to alert citizens in Lexington and Concord of the approaching British troops. The Union Jack is also visible on the flags of the war ships in the harbor, affirming a date before the Revolution.

The legend below the engraving provides the names of eight ships and states that, "on Friday, Sept. 30th 1768, the ships of WAR, armed schooners, transports, etc. came up the harbour and anchored round the town, their cannon loaded," and proceeds to describe the cannon landing on Long Wharf, and the "insolent parade" up King Street that followed.

Henry David Thoreau later wrote fondly in his journal of his visit to Boston's Long Wharf in 1854:

> [I] was surprised to observe that so many of the men on board the shipping were pure country men in dress and habits, and the seaport no more than a country town to which they come a-trading. I found about the wharves, steering the coasters and unloading the ships, men in farmer's dress. As I watched the various craft, successively unfurling their sails and setting to sea, I felt more than for many years inclined to let the wind blow me to other climes.[1]

The importance of the harbor to the city of Boston is evident as it occupies three-fourths of this view. As the harbor gained importance, the Long Wharf:

> ... amounted to a dramatic road from Boston to the sea. Starting at the Town House, the old Cornhill, and Marlborough, Newbury and Orange Streets meandered a mile and a quarter southwest toward the Neck and Roxbury. To the eastward King Street ran straight and wide onto the Long Wharf, where lay the ships that were the source of the town's prosperity. This broad half mile was the obvious avenue to Boston from the part of the world that really mattered.[2]

BOSTON UNIVERSITY ART GALLERY

Following the construction of the Long Wharf in 1710, dock space was significantly increased to accommodate the growing volume of shipping. Once extending from the Old State House along State Street to the harbor and lined with warehouses, its length has been severely truncated, most recently by the construction of the Central Artery in the 1950s.

1. John Aldrich Christie, *Thoreau as World Traveler* (New York: Columbia University Press, 1965), 56.

2. Whitehill, 21.

5. CARTE DU PORTE ET HAVRE DU BOSTON, AVEC LES CÔTES ADJACENTS...

Chevalier de Beaurain
Paris, 1776
colored engraving
82.4 x 95.2 cm
Courtesy of the Norman B. Leventhal
Map Collection

As the British withdrew in defeat because of the Revolution, a significant portion of Boston's population left with them. The departure of the loyalists left a power vacuum in the city to be filled by new faces from the surrounding countryside who attempted to defend what little remained of the English system of authority and privilege. The informal connections that were maintained with Great Britain, however, allowed Boston to continue its success as a commercial center.

This elaborate military map makes reference to the number and power of artillery units, and gives detailed locations of both the American and British troops. The topography of the city and its harbor is elegantly delineated by engraved hachures—short lines used for shading and specifying surfaces in relief. The reliance on an English model for this map is apparent in the way the British fortifications on Boston Neck and Castle Island are exaggerated. Open fields still border the city on the south and west sides, but Boston was to lose its "island character" in the coming decade when the Charles River Bridge finally connected it to Cambridge.

6. THE CITY OF BOSTON AND IMMEDIATE NEIGHBORHOOD

Henry MacIntyre, surveyor
Boston, 1852
lithograph
150 x 197 cm
Harvard Map Collection

The large scale of this map (450 ft. = 1 in.) allows for its great detail. Areas from Somerville and Chelsea, at the top, to Roxbury and Dorchester, at the bottom, are included. Streets, wharves, railroads, homes, schools, and significant buildings can be found on this colorful map, which is one of the most informative and grandest maps created of mid-nineteenth-century Boston.

Images of fifty-five important structures in Boston form the borders. Prominent among these architectural landmarks are the Massachusetts General Hospital, the Old State House, the State House, the Merchant's Exchange, the Athenaeum, the Custom House, and Faneuil Hall. Also featured are the network of railroads leading into the city, the ferries running from East Boston and Chelsea, and the mills powered by the Mill Dam in the Back Bay.

7. A VIEW OF THE PUBLIC GARDEN AND THE BOSTON COMMON FROM ARLINGTON STREET

J. H. Bufford, printer
after a watercolor by Edwin Whitefield
P. R. Stewart & Co., publisher
Boston, 1866
color lithograph
65 x 90.5 cm
Boston Athenaeum

The Boston Public Garden was established in 1839 and at that time a botanical garden was begun by Horace Gray and Charles Francis Barnard, a Unitarian minister.[1] It is hard to imagine that this idyllic garden stood on land once covered with salt marshes and water. In fact, Benjamin Franklin once skated on the frozen water that filled the area of

the garden. Its formality contrasts with the informality of the adjacent Boston Common. In 1859, George V. Meachum designed the Public Garden, drawing on precedents of French parks from the Second Empire. Also in the same year, competitions were held for the surrounding iron fence. The Southworths note that an English pond and a suspension bridge were added in 1861, and that the famous swan boats were not introduced until 1877. This elegant twenty-four-acre garden is adorned with a great variety of trees—weeping willows, beaches, redwoods, and American elms—as well as statues and five granite fountains. At the Commonwealth Avenue entrance, Thomas Bell's equestrian statue of George Washington is one of the most imposing monuments in Boston. The survival of the Public Garden, in "its rigid and highly structured form has helped protect it. The garden accommodates large crowds of people, but their activities are far more restricted than in the Common."[2] Its contribution to the pleasure and delight of inhabitants and visitors is apparent.

1. Southworth and Southworth, 451–53. See too Donlyn Lyndon, *Boston, the City Observed* (New York: Random House, 1982), 122–23.

2. Ibid.

8. CHARLES RIVER BASIN: CONTOUR MAP OF LOWER BASIN

John H. Freeman, engineer and artist
George H. Walker and Co., publishers
Boston, 1902–04
color lithograph
57 x 155 cm
Frances Loeb Library, Graduate School of Design,
Harvard University

Ordered by the Committee on the Charles River Dam, this survey map was made in 1902. A detailed explanatory note describes the "datum plane used for contours and soundings…[as the] Boston City base…the 'mean low water at the Navy Yard' (64' below the base)." Colors appropriate to functions indicate the flats, water, public parks, and recreation.

The map covers an area that extends nearly three miles as the Charles River winds from the east around the Boston & Lowell Freight Bridge to Cambridge Street and River Street. Whereas the map highlights the water levels along the river, it also marks the flats, islands, sewer overflows, temporary dumps, principal bridges spanning the river, and the Fens basin.

On the Boston side of the river, the grid of Back Bay streets is outlined, as is the proposed embankment wall along Back Street (now Storrow Drive). Commonwealth Avenue extends to the boundary line between Boston and Brookline, and northwestward along the Boston & Albany (B & A) Railroad to the Round House at Cambridge Street. On the Cambridge side, the B & A railroad forms a principal axis, as does Massachusetts Avenue, the "Broad Canal" that parallels Main Street and Broadway. Also prominent is the Lechmere canal, and the Esplanade bordering the river, which appears as a broad "park" space.

9. MAP OF BOSTON COMMON WITH SURROUNDING STREETS AND ADJACENT PARTS OF BEACON HILL, 1934

Griswold Tyng, designer
Little, Brown & Co., publisher
Boston, 1934
color lithograph
56 x 71.1 cm
Boston Athenaeum

This colored souvenir map of Boston reveals the Boston Common and the city's streets during the 1930s. In addition to Beacon, Park, Chestnut, Tremont, and Boylston Streets, the open spaces of the Public Garden and Louisburg Square are also represented. Since its founding in 1634, the 48.4-acre irregular pentagon of the Boston Common has served many functions—from cattle grazing and troop encampments to a site for recreation, public gatherings and protests. A wrought iron fence comparable to that of the Public Garden once surrounded the Common, but it was removed and converted to scrap metal during World War II; however, "it was never used because it was of cast

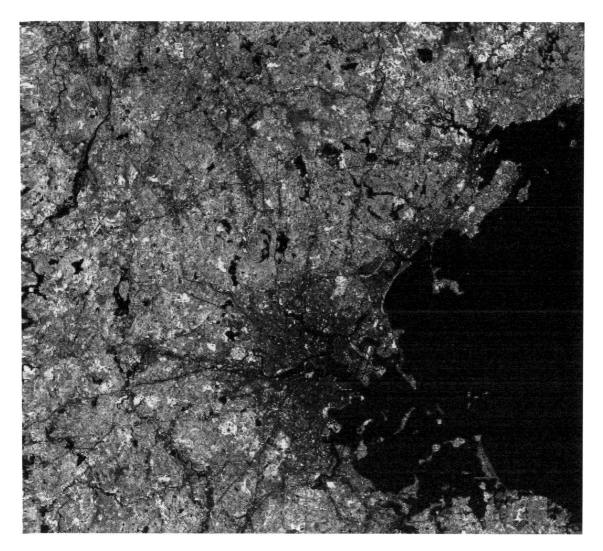

FIGURE 23

Remote Sensing View of Boston, 1993, courtesy of the
Department of Geography, Boston University

rather than wrought iron . . . and was said to have been thrown into the Boston Harbor."[1] In any case, the absence of the fence has contributed to the openness of the Common, especially in relationship to its surroundings.

The Boston Common has always attracted a wide range of recreational and purposeful activities. Prior to the Revolution, Bostonians used it for seasonal sports. Balloon flights, puppet shows, stands selling lemonade and confectioneries, political rallies, and theater performances are some of the activities, amusements, and amenities that have been found here throughout its history. Smoking even became legal on the Common in the mid-nineteenth century.

As part of the Emerald Necklace, "Olmsted's record of achievement in Boston after his defeat in New York City was owing to the social and political support he found there. Boston, unlike New York, still retained an effective intellectual and social elite committed to large-scale environmental planning."[2]

1. Southworth and Southworth, 449.

2. Ibid., 447, citing Albert Fein, *F. L. Olmsted and the American Environmental Tradition* (New York: G. Braziller, 1972).

10. REMOTE SENSING VIEW OF BOSTON

Prof. Curtis Woodcock
1993
satellite photograph
46 x 51 cm
Boston University, Department of Geography

Images such as the one shown above have been collected from space by the LANDSAT series of satellites since 1972. These images record reflected sunlight in a series of spectral bands that cover the visible, near-infrared, and mid-infrared portions of the spectrum. Different surface materials reflect light differently in the various spectral regions such that each material has a "spectral signature" that can be used to help identify it in the images. Pictures from the LANDSAT satellites have been used for a variety of purposes, including agricultural monitoring and inventory, wildlife habitat studies, oil and mineral exploration, forest inventory and monitoring, urban mapping, and water-quality studies. Recently, the archive of images has proven an invaluable record for studying change in landscapes, both due to natural causes and human actions. With these images, we can learn the rate and extent of deforestation, urbanization, and desertification. The successful launch of LANDSAT 7 on 15 April 1999 ensures an ongoing supply of current satellite images.

This image of Boston and the surrounding area was collected on 11 May 1993 from the LANDSAT 5 satellite. This is a "false color" image, as wavelengths of light our eyes do not see have been used. Light from the near-infrared portion of the spectrum appears red in the image. Vegetation is highly reflective in the near-infrared, and hence areas with lots of vegetation read as bright red, particularly parks and golf courses. The forests are still "leafing-out" at this time of year, and thus are not as bright red as the areas of grass. In the green color is light from the mid-infrared, and in the blue color is light normally seen as red. The areas shown cover 3,240 square kilometers at a map scale of 1:118,000.

—C.W.